IMAGES
of Rail

HISTORIC RAILROADS
OF NEBRASKA

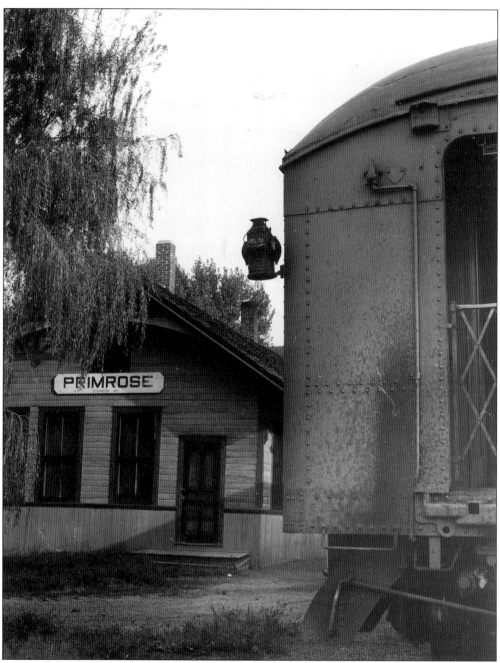

The Union Pacific depot at Primrose and the familiar mixed train presented a scene of rural tranquility on an October day in 1957. In 1902 the UP had extended a branch, which had long terminated at Cedar Rapids, up the Cedar River Valley through Primrose to Spalding. A deadly tornado on May 8, 1965, destroyed the depot and much of Primrose. But residents of the small town prevailed, and Primrose celebrated its centennial in 2002. Meanwhile, flood damage from 2001 threatens the future of the 44-mile branch line from Genoa to Spalding, now operated by the Nebraska Central Railroad. (William W. Kratville.)

IMAGES
of Rail

HISTORIC RAILROADS
OF NEBRASKA

Michael M. Bartels & James J. Reisdorff

ARCADIA

First Printed 2002.
Reprinted 2003.

Published by Arcadia Publishing,
an imprint of Tempus Publishing, Inc.
Charleston SC, Chicago, Portsmouth NH,
San Francisco

Printed in Great Britain.

Library of Congress Catalog Card Number: 2002110451

For all general information contact Arcadia Publishing at:
Telephone 843-853-2070
Fax 843-853-0044
E-Mail sales@arcadiapublishing.com

For customer service and orders:
Toll-Free 1-888-313-2665

Visit us on the internet at http://www.arcadiapublishing.com

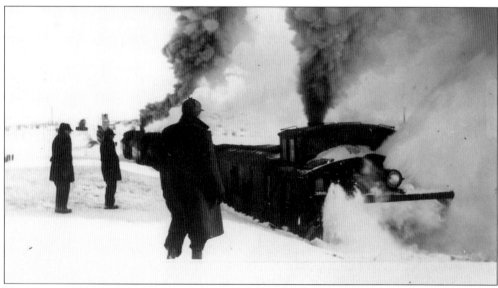

The winter of 1948–49 is considered the worst of modern times in much of the West. Blizzards even shut down the busy Union Pacific main line across Nebraska and Wyoming, stranding several streamlined trains full of passengers. The situation on the branch lines was even worse. The only way to clear them was with a rotary snowplow, after the main lines had been reopened. This scene was along the Burlington branches in southwest Nebraska that ran to Oberlin and St. Francis, Kansas. (High Plains Historical Society.)

CONTENTS

ACKNOWLEDGMENTS

In his 1990 book, *Kearney & Black Hills*, railroad historian Francis G. Gschwind of Callaway stated: "To a youngster who worshipped at the altar of the Iron Horse, a friendly wave from him (the engineer) as the train rolled past, was a greater honor than a handshake from the President of the United States could ever have been."

The same sentiments might otherwise be shared by anyone who can appreciate trains and what the legacy of the railroad industry has meant to the development of both Nebraska and America. While it is not possible to completely synopsize almost 140 years of railroad service to Nebraska between the covers of one book, it is hoped that what is compiled here can serve as a pictorial primer on the subject, and can foster a better understanding of Nebraska's railroad experience for readers new to the subject. To those—either as railroad employee or railroad buff—who are already well versed in the information that follows, we hope this effort to highlight the story in pictures is met with an affable eye.

Admittedly, an account of the state's larger railroad terminals is deserving of more attention than was possible here. While a number of such books have already been published in years past by various authors, (the bibliography on page 127 might serve as a starting point for the reader), still more are planned. A pictorial on the railroad history of the Omaha and Council Bluffs, Iowa, vicinity will be compiled by longtime Union Pacific historian William W. Kratville and printed by Arcadia Publishing. For that reason we have largely left the subject of Omaha area railroading for Bill to explore in more detail.

As for this effort, we wish to express our sincere appreciation to the following individuals and institutions for their assistance in making this work possible. Those railroad enthusiasts who generously provided photographs from their collections include Forrest H. Bahm, Charles W. Bohi, Thomas O. Dutch, Robert Eddy, James L. Ehernberger, Michael B. Foley, Charles Furst, Lawrence Gibbs, H. Roger Grant, Francis G. Gschwind, L. A. Haman, Alfred J. Holck, Thomas W. Jurgens, Richard H. Kindig, Richard C. Kistler, William W. Kratville, James McKee, Alfred Novacek, A. J. Pfeiffer, Nicholas L. Pitsch, William F. Rapp, James C. Seacrest, Richard L. Schmeling, Michael Varney, and H. K. Vollrath. Posthumous credit for their help must given to the late John H. Conant, Bernard G. Corbin, Virl Davis, Joseph C. Hardy, and Arthur E. Stensvad.

County or town history organizations and museums that provided photographs are the Adams County Historical Society, Alliance Knight Museum, Burt County Historical Society, Dawes County Historical Society, Dodge County Historical Society, Fairbury Museum, High Plains Historical Society (McCook), Saline County Historical Society, and Saunders County Historical Society.

For assistance with major photo collections, we thank the staff of the Nebraska State Historical

Society in Lincoln and the Union Pacific Museum in Omaha.

A thank you goes to Jerry Penry for producing the railroad map of Nebraska that appears on page 10.

All photographs not otherwise credited are by James J. Reisdorff.

Our appreciation is extended to Oliver B. Pollak for initially informing us about the efforts of Arcadia Publishing to provide authors with an outlet for publishing regional history. And a big thank you to the staff and editors at Arcadia for their interest and support of this project.

Our sincere apologies are otherwise extended to anyone we might have unintentionally overlooked here.

The Internet has allowed for a host of websites devoted to various Nebraska rail-related subjects, including railfan and model railroad clubs, railroad museums, railroad employee genealogy, and others. Those searching for any such information are welcome to contact us at railroads@alltel.net with any questions. We will endeavor to help as possible on a time-available basis.

Michael M. Bartels
James J. Reisdorff

INTRODUCTION

Railroads have been one of the most dominant forces in shaping Nebraska. They were largely responsible for the creation of many of its towns, which were platted by townsite companies at designated station points along the new lines. Thus the peak years of railroad construction, 1886 and 1887, were also the most active years for town founding. Rail routes were later followed by highways, further solidifying these settlement patterns and transportation corridors.

Five major railroads served Nebraska, in addition to several that came across Iowa and had a small presence in Omaha. Burlington Northern & Santa Fe operates the most mileage in the state, with 1,710 miles in the year 2000, primarily running south of the Platte River, but also along a busy coal corridor across the Sandhills to Alliance, where it then splits into key feeders to the northwest via Crawford and south to the North Platte Valley and Colorado. The original Burlington & Missouri River in Nebraska Railroad, which built the first line between 1869 and 1872, was acquired by the Chicago, Burlington & Quincy in 1880, although it wasn't fully merged into the CB&Q until 1904. The CB&Q became part of the new Burlington Northern, created by a March 1970 merger of major Northern railroads. In the mid-1990s Burlington Northern and the storied Atchison, Topeka & Santa Fe merged to form Burlington Northern & Santa Fe Railway.

Union Pacific was Nebraska's first railroad, building across the state between 1865 and 1867, on its way to meet with the Central Pacific to complete the nation's first transcontinental railroad. The UP, at its peak in 1927, operated 1,358.11 miles in Nebraska, down to 1,003.5 by

2002. The latter figure reflects UP's merger with two other railroads that had a significant presence in Nebraska. In 1995, it acquired the Chicago & North Western, once the major railroad in northern Nebraska before extensive line abandonments. In 1982, UP had acquired the Missouri Pacific, which reached Omaha and Hastings from the south. The Rock Island Line of folksong fame—formally the Chicago, Rock Island & Pacific, which cut across southeast Nebraska—was shut down for liquidation at the end of March 1980. UP operates 37.4 miles of former Rock Island trackage between Fairbury and Nebraska Public Power District's Sheldon Station north of Hallam. This segment is leased from a Kansas-based port authority that bought it from the Rock Island bankruptcy trustee in 1984.

In recent years, major railroads have sold or leased significant segments of secondary trackage to new short lines or regional railroads as an alternative to outright abandonment. The "spin-offs" capitalize on lower operating costs and personalized service to secure business, with the larger roads preferring to concentrate on higher-volume traffic. As of 2002, there were seven regional or local railroads operating in the state. They include Nebraska Central, which operates a package of 282 miles, mostly leased Union Pacific branches; Nebraska Kansas Colorado RailNet, operating 231 miles of ex-Burlington Northern trackage in southwest Nebraska; and Nebraska Northeastern, operating 120 miles from near South Sioux City to O'Neill, also former BN mileage. Nebkota Railway operates 103 miles of former Chicago & North Western trackage in northwest Nebraska, including trackage rights from Chadron to Crawford. The Chadron-Crawford line, and a connection to South Dakota (39 miles total), is owned by Dakota, Minnesota & Eastern Railroad, another C&NW spin-off. Kyle Railroad operates 56 miles of former BNSF trackage from southeast Lincoln to Omaha Public Power District's Nebraska City Station under contract for the power district, which bought the line from BNSF.

Three switching roads operate smaller segments. Sidney & Lowe Railroad operates 11 miles at the former Sioux Army Depot near Sidney, which has been redeveloped as an industrial park. Omaha, Lincoln & Beatrice Railway, a onetime electric interurban, switches two miles of track in Lincoln. Brandon Corp. switches two miles in Omaha at the site of the former South Omaha stockyards and serves a freight car repair shop owned by its parent, Rail Car America. Several other spin-offs have shut down after unsuccessfully trying to get a niche in the state's transportation picture.

While Nebraska rail mileage has dropped from its peak of 6,248.53 in 1926 to 3,537 in 2000, the state is home to the largest freight classification yard in the world (Bailey Yard in North Platte). Upwards of 135 trains a day or more cross the busy UP main line through the central Platte Valley. The railroad is securing its ties to downtown Omaha with construction of a new 19-story headquarters, expected to open in mid-2004. Burlington Northern & Santa Fe also handles a heavy volume of coal traffic east from Wyoming's Powder River Basin. In 2000, Nebraska ranked third in the number of freight railroad employees, 10,592, behind only Texas and Illinois. The annual total wages paid them, $627,661,000, demonstrates that railroads remain a powerful engine of the Nebraska economy, as they have been over the past 140 years.

One
LAYING TRACKS

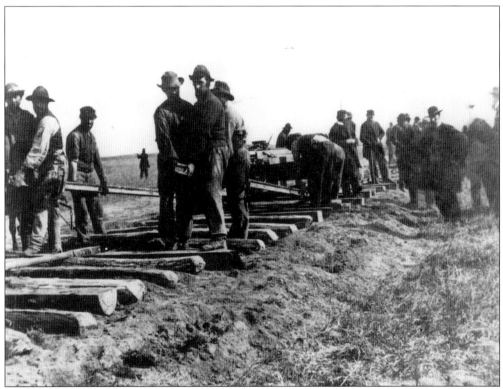

The advance of Union Pacific tracklayers west across Nebraska was part of America's great adventure of the 19th century: building the first transcontinental railroad. Two years after the December 1863 groundbreaking in Omaha, UP rails finally began moving west in July 1865. Tracklayers' ranks now swelled with Civil War veterans and immigrants, including the storied Irish workers, bossed by the Casement Brothers. They reached North Platte in late 1866 and crossed into Wyoming Territory before the end of 1867. The Golden Spike was driven on May 10, 1869, at Promontory, Utah Territory. Next came filling out the system with branches and the bringing of settlers to the lands along the new lines. (Nebraska State Historical Society.)

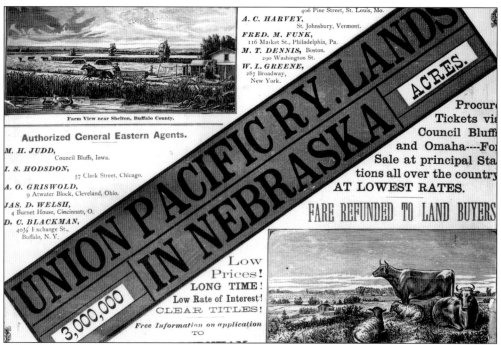

Posters like this were just one example of efforts railroads used to attract settlers to lands along the tracks. Land grants had given some railroads broad strips of alternate sections to sell, while the federal government retained the rest to market. In Nebraska and the Dakotas, settlers would test the western limits of arable land suitable for cultivation. The expansive 1880s experienced a period of abundant rainfall, a situation that would drastically change by the 1890s. (Nebraska State Historical Society.)

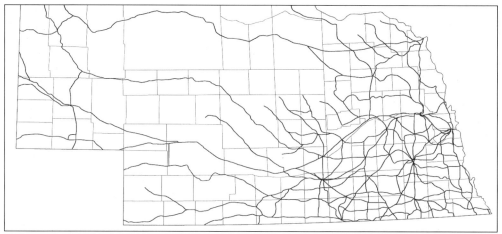

This map of Nebraska shows all railroad lines that have been constructed in the state since 1865. The eastern portion of the state, with its rich agricultural land, was at one time laced with secondary main and branch lines. The west central and northwestern region, with its less-populous Sandhills terrain, was penetrated by only a few lines aiming to reach the Black Hills of South Dakota or connections to the Pacific Northwest. To reduce both construction costs and track gradients, many rail lines were built along routes coinciding with major river valleys. (Map courtesy of Jerry Penry.)

10

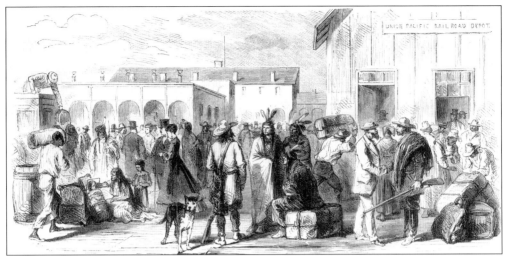

This Omaha depot scene was pictured in an 1868 German publication. It became familiar to many immigrants who made their way to Nebraska. Railroads encouraged settlement along their lines by dispatching colonization agents to European countries and by printing promotional literature in different languages. Special cars and rates were also offered to immigrants. In addition, they also handled many moves by settlers within the country. The Burlington & Missouri River even erected an immigrant house near today's Henderson to house newly arrived German-Russian Mennonites in the 1870s. (Union Pacific Museum.)

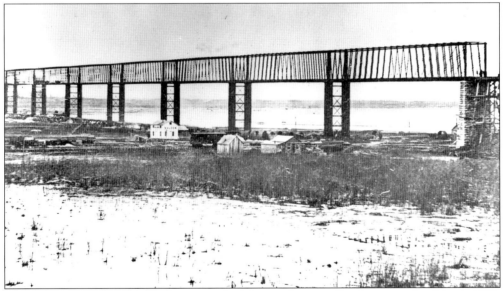

The original Union Pacific bridge across the Missouri River at Omaha, opened in March 1872, probably didn't inspire confidence among travelers, but it was an engineering marvel for its day, employing the "pneumatic" method of pier construction that also left workers subject to the bends. A tornado early on August 25, 1877, didn't help either: it destroyed two spans, or about 500 feet, on the east end. However, it was a permanent bridge, eliminating the need for transfer boats and the temporary "winter bridges." It was replaced by a more substantial structure in October 1887, which in turn was replaced by a new superstructure in December 1917. The latter is still in use. (Union Pacific Museum.)

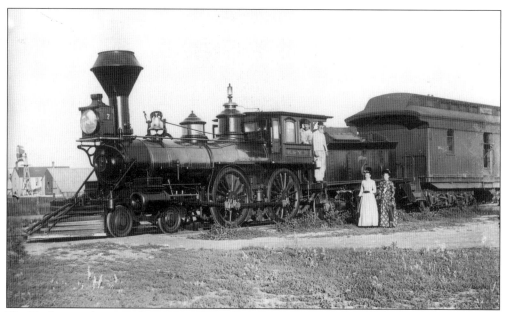

The Burlington began a dramatic push to the northwest starting in 1886 at Grand Island. By that fall it had reached Broken Bow, an existing settlement in Custer County that boomed with the coming of the railroad. An early train is shown there in 1886 or 1887. By early 1888, it had crossed the Sandhills and reached what would be the new town of Alliance. By 1890, it was into the Black Hills of South Dakota. A connection was made with the Northern Pacific east of Billings, Montana, in 1894 to form a through-route to the Pacific Northwest. (Nebraska State Historical Society.)

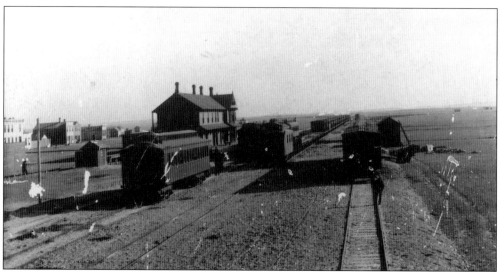

Arrival of the Burlington's Grand Island & Wyoming Central subsidiary in the Nebraska Panhandle early in 1888 spurred the founding of Alliance. Even at the time of this photo, it was still a new town out on the flat Box Butte Table. The railroad has always been the driving economic force in the city, especially since 1969, when the Wyoming coal boom brought big gains in local rail employment. The city grew from 6,862 in 1970 to 9,920 in 1980. (Alliance Knight Museum.)

Oakdale became end of the line in 1879, when the Fremont, Elkhorn & Missouri Valley (then operated by the Sioux City & Pacific) finally advanced up the Elkhorn Valley from Wisner, its terminus since 1871. But in 1880, tracklayers moved west to Neligh, and by the end of 1885, they had crossed northern Nebraska and had entered the Black Hills country. Oakdale became a junction in 1887 when a secondary line from Scribner via Albion was completed. This photo may be of the first train on that branch. (Nebraska State Historical Society.)

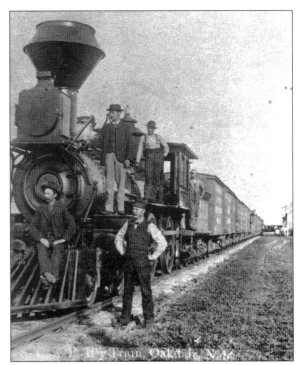

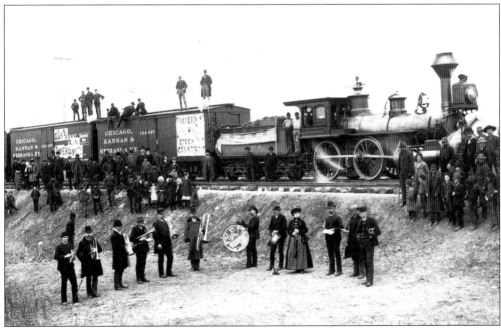

Hebron celebrated completion of its second railroad with a special corn train intended to generate interest in Thayer County, especially among prospective settlers as it headed east. The Chicago, Kansas & Nebraska, a Rock Island subsidiary, laid track as far west as Nelson in 1887, then decided to build its Colorado extension southwest from Fairbury. Even though Hebron was soon on a branch line instead of a main route, Rock Island trains came through the town until 1973. (James J. Reisdorff collection, courtesy of Thomas Lucht.)

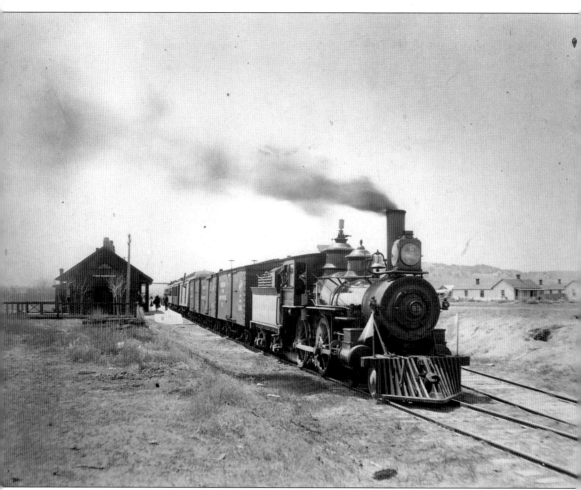

Historic Fort Robinson, a cavalry post that figured prominently in the Indian Wars and remained active until 1948, was a separate station on the Chicago & North Western. The railroad arrived in 1886, 12 years after the fort was established. A train is shown here around 1905. The northwestern Nebraska fort was home to "Buffalo Soldier" units and later served as a cavalry remount depot, a K-9 Corps training facility, and a World War II prisoner-of-war camp. All of this generated rail activity. The C&NW agency was closed in April 1947 as post-war activity wound down. Fort Robinson is now a state park. A trail using the former C&NW right-of-way links it to nearby Crawford. (Nebraska State Historical Society.)

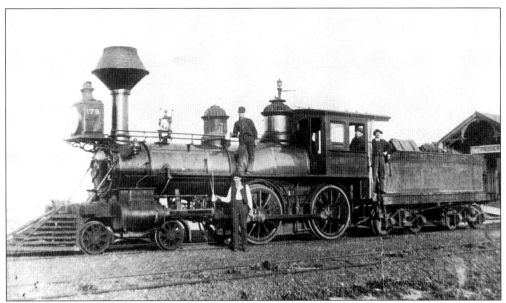

A Missouri Pacific predecessor had built an extension through Hastings into the northwest corner of Adams County in 1888. Prosser, named after a railroad contractor, was created as a town at the end of the line. Here 4-4-0 No. 179 and crew pose at Prosser in the early years. Despite persistent pleas by Kearney, the Missouri Pacific never ventured beyond Prosser. By early 1944, it had retreated to Hastings. A Union Pacific freight cutoff, completed in 1913, passed not far to the south of Prosser, which gained a rival for business at the new shipping point of Hayland. (Adams County Historical Society.)

This train on the Union Pacific at Loup City was typical of the "mixed trains," carrying both freight and passengers, seen on many Nebraska branch lines. It would soon head down the scenic Middle Loup Valley for St. Paul, where it would connect with another UP branch bound for Grand Island. The Burlington also served Loup City, reaching St. Paul via another route, and extending northwest to Sargent. (Union Pacific Museum.)

Palmer had visions of being a major junction on the Burlington's Lincoln & Black Hills subsidiary, as evidenced by construction of this five-stall brick roundhouse. But the extensions into the Sandhills ended at Burwell, Ericson, and Sargent, then dissipated into unused roadbeds graded beyond those points. Palmer was left as just an ordinary branch-line junction. (James J. Reisdorff collection.)

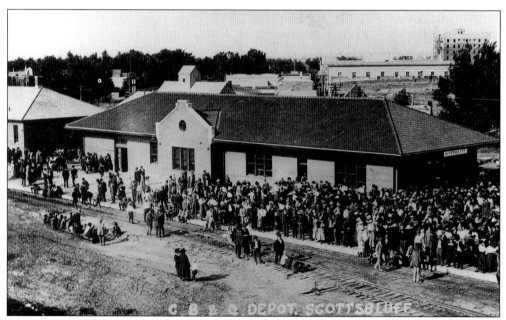

Scottsbluff was founded at the same time that the Burlington advanced up the North Platte Valley in 1900. It grew to become the largest city in the Nebraska Panhandle, outpacing older Gering across the river. One measure of its rising status was completion of a new brick passenger depot, supplanting the original wooden structure. In the background, another indicator of civic progress, a modern hotel, was going up. (Nebraska State Historical Society.)

Extension of a Union Pacific branch line from Stromsburg to Central City in 1906–1907 turned it into a secondary through-route suitable for detours of main line trains if needed. It also prompted the creation of two new towns, Polk, shown here, and Hordville. By then, the era of railroad construction and related townsite development at new stations en route was almost over in eastern Nebraska. Another latecomer in the east had been the Burlington extension from Ashland to South Sioux City via Fremont, completed in 1906. (Nebraska State Historical Society.)

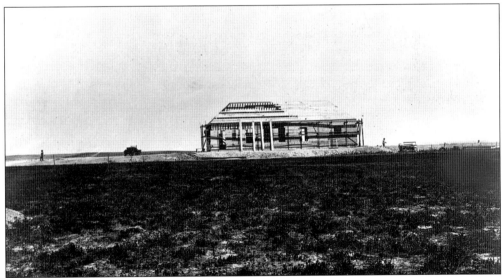

Lyman, in far western Nebraska, was the last new town created as part of railroad construction. Union Pacific was pushing west from Haig, west of Gering, into eastern Wyoming. The depot, shown on September 1, 1921, was taking shape in otherwise desolate surroundings. The fact that someone has apparently driven up to the building portends a major change in community development. The automobile would be the driving force in the future growth of suburbs and the subsequent problem of urban sprawl. (Nebraska State Historical Society.)

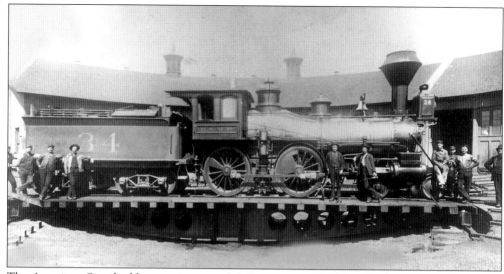

The American Standard locomotive, or a 4-4-0, meaning it had four leading truck wheels, four drivers, and no trailing truck, was the standard of American railroading in the 19th century. This photo of Burlington & Missouri River 4-4-0 No. 34 was taken at a busy roundhouse in Nebraska, believed to be either McCook or Wymore. Other large roundhouses in this era were at Lincoln, Plattsmouth, and Alliance. The 4-4-0s were replaced by larger, more powerful locomotives. A few did remain in local service into the 1930s. (Saline County Historical Society.)

A major obstacle to the Fremont, Elkhorn & Missouri Valley's advance across northern Nebraska was the Niobrara River. It took months to construct this bridge and to cut through a large hill nearby. Trains finally crossed and entered the new town of Valentine in the spring of 1883. The track here nicked a corner of the Fort Niobrara military reservation. This bridge was replaced by a 140-foot-high steel viaduct in 1909–1910, which required the construction of 5.73 miles of new track. (Nebraska State Historical Society.)

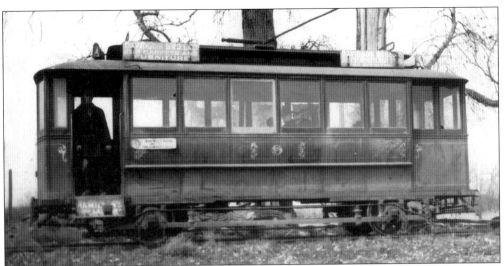

Nebraska had few electric interurbans, unlike other states. However, suburban lines did extend out from Omaha, Lincoln, and South Sioux City, in addition to urban streetcar lines in the larger towns. One of these suburban lines was the Sioux City, Crystal Lake & Homer Railway, which linked South Sioux City and Dakota City. It was built in 1904 and electrified in 1910. One of its cars is pictured here near the time of its shutdown in May 1918. Electric streetcars operated in Lincoln until September 1945 and in Omaha until March 1955. (Nebraska State Historical Society.)

Railroads once interlaced portions of Nebraska like strands of spaghetti. Three crossed at the south edge of Wahoo until the early 1980s. A Union Pacific secondary line from Valley to Lincoln and Beatrice crossed from left to right, while a Chicago & North Western branch from Fremont to Lincoln entered at the lower left. A Burlington branch that once extended from Ashland to Schuyler enters at the lower right. By the time of this photo on June 22, 1968, it had been cut back to Prague. Both it and the C&NW branch are now abandoned. The wooded area near the intersecting tracks was once the site of a hobo jungle. (Bernard G. Corbin, James J. Reisdorff collection.)

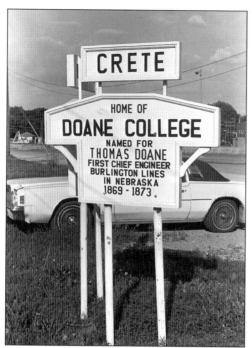

The Burlington & Missouri River had an especially lasting impact on Crete, starting when the first train arrived on June 12, 1871. Its chief engineer, Thomas Doane, who achieved fame for his work on Massachusetts' Hoosac Tunnel, founded his namesake college on behalf of Congregationalists. This sign at the depot welcomed many students who arrived by train until May 1, 1971, when the Crete stop was discontinued as part of the Amtrak takeover.

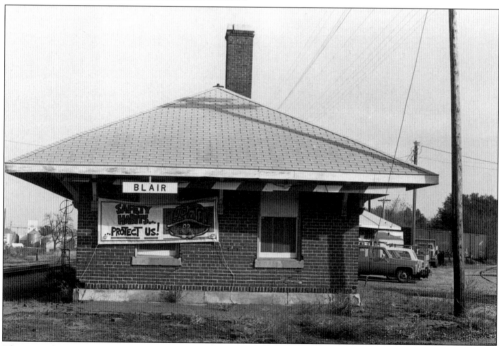

Blair, Nebraska, was named for John I. Blair, a major railroad builder associated with the Chicago & North Western. This town is typical of many across Nebraska that were named for a person connected with the railroad company that established and served those communities. The Blair depot, built in 1910, served both the C&NW line from Missouri Valley, Iowa, to Fremont and its Chicago, St. Paul, Minneapolis & Omaha subsidiary, which ran north from Omaha through Blair to Sioux City, Iowa.

Two

BUILDING A STATE

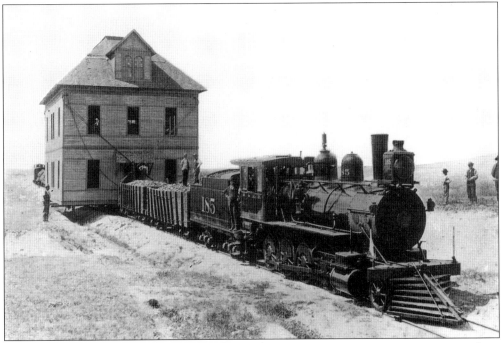

The new townsites platted along railroads soon began trying to wrest county seats away from established communities—or each other. Hemingford had won the county seat of Box Butte County from Nonpareil in 1890, but lost it in another hard-fought election in 1899 to Alliance, a faster-growing town with a big railroad payroll. The courthouse was simply loaded on a Burlington train and moved to Alliance. But the Burlington town of Curtis could never get the Frontier County seat away from trainless Stockville. Communities that lacked rail service were known as "inland towns" in this era. (Nebraska State Historical Society.)

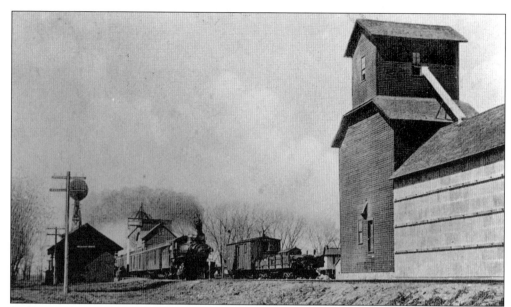

A Chicago & North Western train is shown at Meadow Grove, west of Norfolk. The trackside grain elevator was as much a part of the rail scene as the depot. The bounty of the fertile Elkhorn Valley would be shipped out from here in rail cars. The elevators have become larger, as have the cars used for grain shipment, but the basic importance of railroads to agriculture remains. (L.A. Haman collection.)

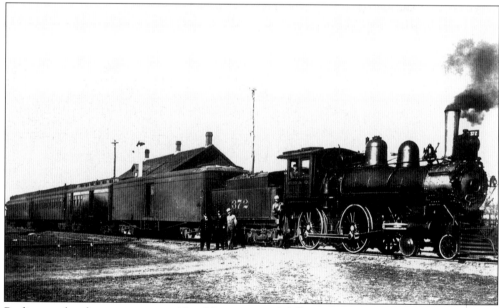

Burlington local passenger train No. 90 pauses at Odell, just after completing a trip up the branch from Concordia, Kansas. The next stop will be the division point of Wymore, where several trains will meet to exchange passengers, mail, and express. From there, No. 90 will continue on to Lincoln, returning as No. 89 to Concordia the next day. They were just part of an extensive network of passenger trains on interlacing routes across the state that provided ready access to most towns. (Nebraska State Historical Society.)

The 22nd Infantry from Fort Crook, south of Omaha, had traveled via the Chicago, St. Paul, Minneapolis & Omaha to Bancroft for target practice on the rifle range at the Omaha Indian Reservation. Information with this photo, dated June 27, 1903, stated the soldiers drank the town's saloons dry that Saturday night. The man sitting on the logs may have been John G. Neihardt, a Bancroft native who would gain fame as author of "Black Elk Speaks" and as Nebraska's poet laureate. (Nebraska State Historical Society.)

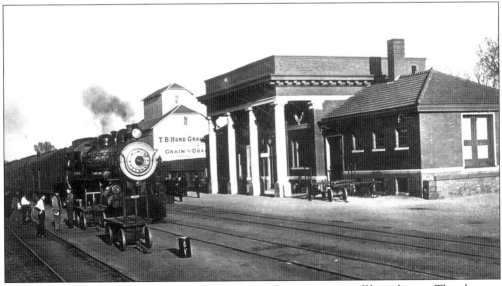

The Union Pacific depot at Central City was a stately structure set off by columns. The elevator in the background was part of the once-extensive T.B. Hord chain of grain elevators, banks, lumberyards, and other businesses based in Central City. This was also the hometown of author and photographer Wright Morris, who often fictionalized it as Lone Tree, the original name of the settlement. It was changed to Central City in 1875 to attract more settlers. (Nebraska State Historical Society.)

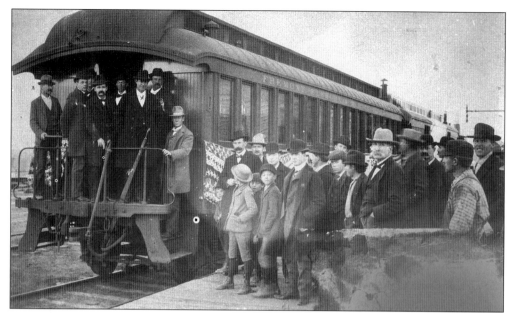

William Jennings Bryan, at right front on the coach platform, was making a campaign stop at Chadron in 1896. The "Great Commoner," who spent much of his adult life in Lincoln, was the Democratic presidential nominee in 1896, 1900, and 1908. He traveled thousands of miles by rail for those unsuccessful campaigns, as well as for many speaking engagements over the years. The coach is still lettered for Fremont, Elkhorn & Missouri Valley, which operated the northern Nebraska line until it merged with parent-company Chicago & North Western in 1903. (Dawes County Historical Society.)

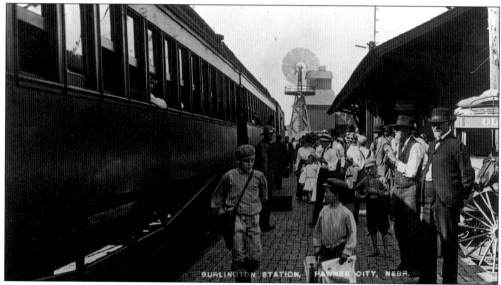

At the turn of the 20th century, the daily arrival of a local passenger train provided small town residents with opportunities for both business and entertainment. A photographer at Pawnee City caught this image in 1912 on the bricked platform of the Burlington depot during "train time." Young boys sell newspapers to travelers, while it's suspected others are there just to watch the activity. (Nebraska State Historical Society.)

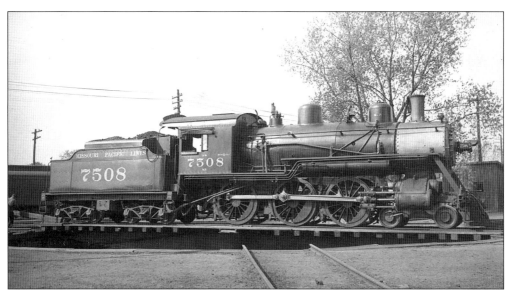

A Missouri Pacific 4-6-0 is being turned on the turntable at Lincoln in May 1934. The Ten Wheeler was used on the daily passenger runs to Union, which connected with trains to Kansas City and St. Louis. Recalling the era when locomotives were the pride of their assigned crews, the 7508 got special attention from the Lincoln roundhouse force, an effort commended in the company magazine. (Harold K. Vollrath collection.)

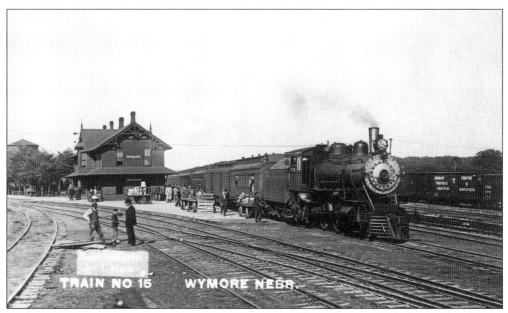

Burlington passenger train No. 15 pauses at Wymore in the early 1900s. The busy railroad town saw two through passenger trains each way between St. Louis, Kansas City, and Denver, plus two pairs to Lincoln on the tracks to the left and additional local service. Freight traffic, including heavy movements of eastbound livestock, kept many more train crews busy. This activity also required a large force at the roundhouse and shops. (Nebraska State Historical Society.)

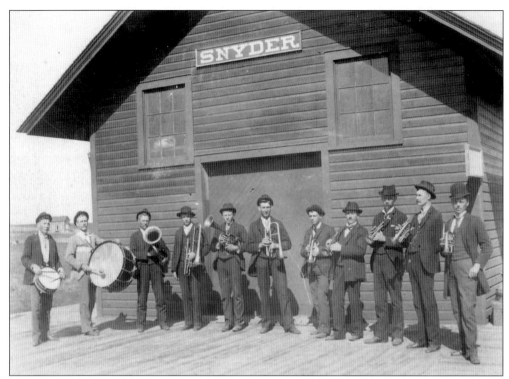

It was a day to strike up the band at Snyder, a town on the Chicago & North Western's long branch line from Scribner to Oakdale via Albion. Whether they were greeting or sending off a noteworthy passenger or preparing for a group trip is no longer known. (James J. Reisdorff collection.)

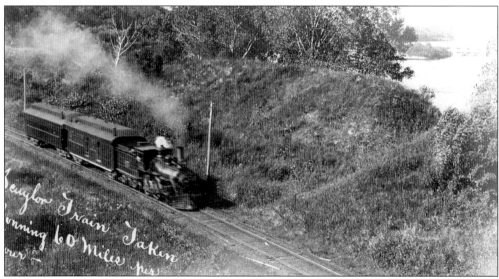

Local passenger trains seemed to stop at every station, but they could "go like 60" between towns to stay on schedule. The Burlington's train from Schuyler is scurrying along one-fourth mile east of Louisville in 1908. Besides calling at towns on the Ashland-Schuyler branch, it also served the original Burlington & Missouri River main line east to Plattsmouth. Its schedule allowed for several hours in Omaha to transact business. (Bernard G. Corbin, James J. Reisdorff collection.)

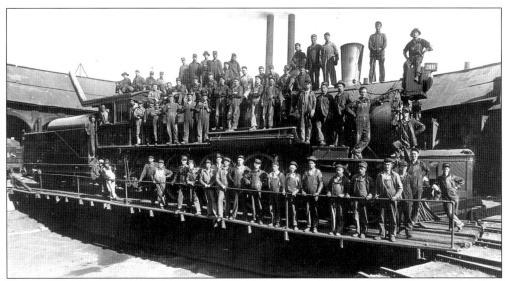

The Burlington roundhouse force at McCook poses for a group photo on 4-6-2 No. 2811. Roundhouses were located at all major terminals. Here, steam locomotives were serviced between runs. Minor repairs could be done here, although heavier work required a trip to the shops. On Burlington lines west of the Missouri River, this was done at either Havelock (until it was converted to freight car work in 1931) or the new locomotive shop in Denver, opened in December 1923. Steam locomotives were once assigned to crews and engines were changed at the end of each crew district. (High Plains Historical Society.)

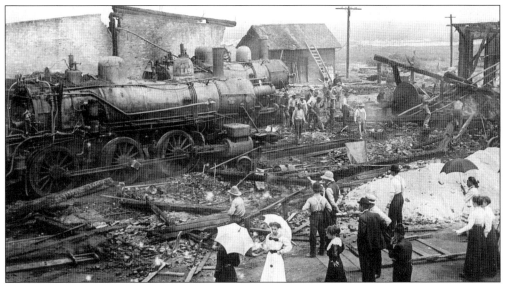

With wood, oil, and flames in abundance, roundhouses had a great potential for fire. This one, in August 1910, destroyed the Chicago & North Western roundhouse at Chadron and several locomotives inside, though it was rebuilt. A particular hazard of steam operation was the boiler explosion, a rare but catastrophic event that often meant death to anyone nearby. Allowing the water to get too low over the firebox crown sheet was the most frequent cause. Engines also ended up in the turntable pit and a few ran through the outer roundhouse wall due to human or mechanical failure. (Dawes County Historical Society.)

With starched collars and ribbons, Omaha boosters had settled in for a long trade excursion to Bonesteel, South Dakota, on the Chicago & North Western in May 1905. Omaha, Lincoln and other cities made numerous promotional outings in these years to spread goodwill throughout their tributary territories. In later years, civic boosters used chartered buses or auto caravans, although Omaha's Tribe of Yessir continued to make rail trips into the 1970s. (Nebraska State Historical Society.)

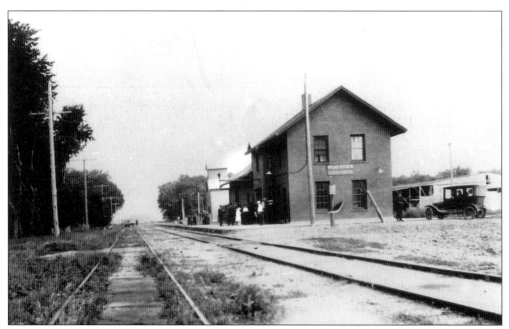

This 1920s view looks northwest up the Chicago & North Western track at Plainview. The town had the most impressive depot on the 208-mile branch from Norfolk to Wood, South Dakota, as it had a brick veneer. Passenger service through Plainview ended in September 1951; C&NW freight operation ceased here in June 1978. The depot remains on site as part of a local museum. (James J. Reisdorff collection.)

The Burlington section crew is shown at Diller in 1885. The hand-propelled car and the workers' attire are standard for the era. At first every town had a section crew assigned to maintain several miles of track. A dwelling or section house was provided for the foreman. Living quarters were also offered to the station agent in the second floor of the depot. The balcony is an unusual feature. Mechanization and reductions in maintenance forces resulted in crew consolidation and expanded jurisdictions. (William F. Rapp collection.)

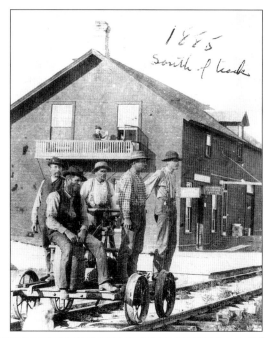

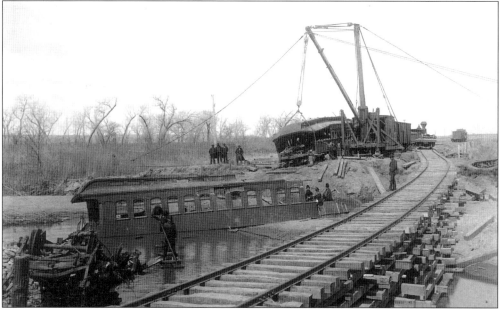

The early years of rail travel were often marked by serious accidents. This one occurred at Rope Creek between Orleans and Alma on the Burlington on April 27, 1888. The eastbound Kansas City flyer went through a bridge undermined by flooding. Two passengers were killed and seven other people were injured. Washouts accounted for some of the worst accidents in Western railroading. The deadliest accident in Nebraska came on May 29, 1911, when Burlington passenger trains Nos. 9 and 12 collided head-on, a half-mile west of Indianola. Eighteen were killed and twenty-two or more were seriously injured. Steel cars, automatic block signals, and other improvements helped turn railroading into the safest mode of transportation, even at a time when average speed increased significantly. (Nebraska State Historical Society.)

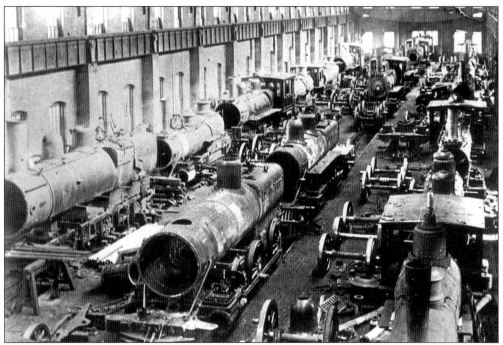

The Burlington & Missouri River constructed a locomotive shop at Havelock, a new town platted northeast of Lincoln in the early 1890s. It was significantly expanded in 1909–1910. Not only did it build locomotives, it rebuilt others and did heavy repairs that couldn't be performed at local roundhouses. It was roiled by the turmoil of the nationwide 1922 rail shopcraft strike and closed for a time during the Great Depression. Havelock was converted to freight car work in 1931. In addition to repairs, it also manufactured freight equipment and baggage cars. Until this work went to contractors in the late 1960s, more than 55,000 cars had been built at Havelock. Today it's the main heavy freight car shop for the Burlington Northern & Santa Fe system. Havelock was a separate city until it was annexed by Lincoln in 1930. (James J. Reisdorff collection.)

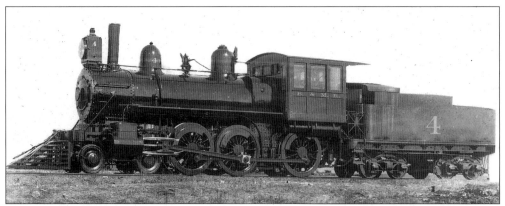

Burlington & Missouri River 4-6-0 No. 4 (later Chicago, Burlington & Quincy No. 658, retired in January 1933) was the first locomotive built at the road's Havelock Shops in 1895. A total of 70 steamers would be built here before production ended in 1913. Three have been preserved and are on display: Nos. 710 at Lincoln, 719 at Alliance, and 915 at Council Bluffs, Iowa. Locomotive manufacture generally became the province of specialized builders. (Nebraska State Historical Society.)

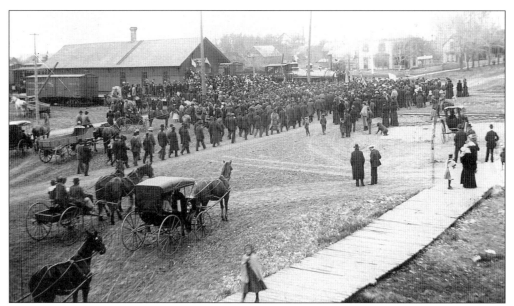

Butler County residents gave the local Company E Volunteers a patriotic farewell at David City's Fremont, Elkhorn & Missouri Valley (Chicago & North Western) depot in April 1898. The state militia was called up for active duty during the Spanish-American War. Such scenes were repeated less than 20 years later when large groups of draftees left for World War I and again during World War II. Mass hometown departures by rail weren't generally seen in later wars, however. (James J. Reisdorff collection.)

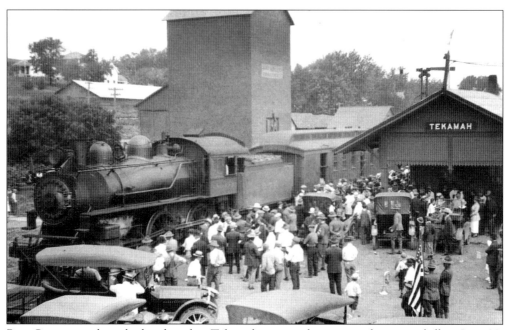

Burt County residents had gathered at Tekamah to give their men a fitting sendoff on June 28, 1918, as they boarded a special train for military training camps. This scene was repeated at towns across the country as draftees left on the journey that took many to the trenches of France. For some, this would be their last view of their hometown. (Burt County Historical Society.)

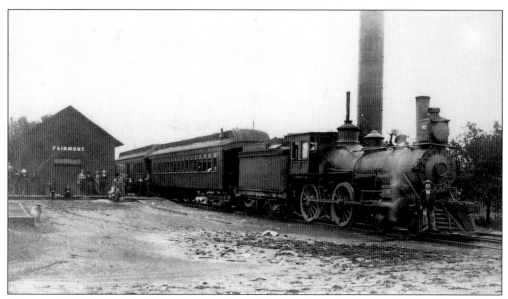

A two-car Burlington local passenger train makes a stop at Fairmont. The town, midway between Lincoln and Hastings on the main line, was also a transfer point for branch lines to the north, south, and southeast. The wooden depot was later replaced by an impressive brick and stucco structure, which still stands. Fairmont became well known to World War II airmen, as a major training base was located south of town. Troops arrived and departed by the trainload, in addition to smaller groups. Fairmont also became a highway crossroads, where the Meridian Highway (US-81) met the DLD (US-6). Traffic on the latter declined sharply with construction of Interstate 80 to the north. (Nebraska State Historical Society.)

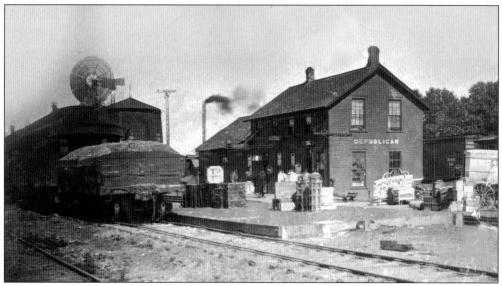

The town called Republican City was just Republican to the Burlington, eschewing the "City" here, as it did at Mason and Pawnee. From here a branch off the Republican Valley main line followed Prairie Dog Creek to Oberlin, Kansas. Flood control efforts in the wake of the 1935 disaster doomed the old town. Republican City moved to higher ground in 1951 to make way for a reservoir behind Harlan County Dam. (James J. Reisdorff collection.)

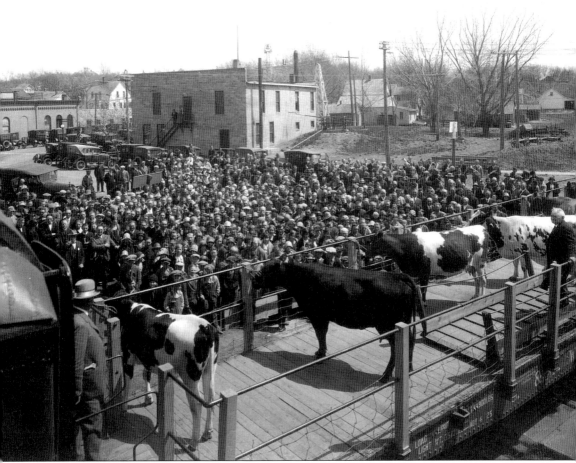

Railroads continued to play an active role in agricultural development after settlers were on the land. In conjunction with universities and other organizations, they sponsored demonstration trains that toured their lines, offering farmers, ranchers, and dairymen the chance to learn about ways to improve production. This University of Nebraska special was touring the Chicago & North Western. It's shown at Leigh on April 26, 1926. This work later was taken over almost entirely by university extension services. Still, Union Pacific offered rental films on livestock and agricultural subjects into the 1960s. (Nebraska State Historical Society.)

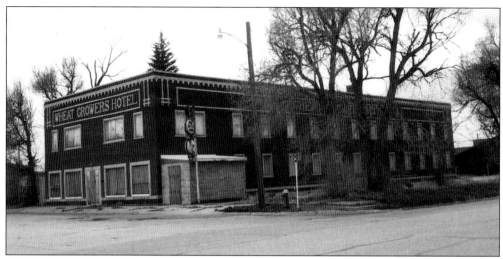

The railroad built the hotel, just as the automobile built the motel. The impressive Wheat Growers Hotel at Kimball, along the Union Pacific in the Nebraska Panhandle, served commercial travelers who arrived by train as well as motorists on the Lincoln Highway and successor US-30. However, travelers left the passenger train and the old highways behind as they turned to Interstate 80 and chain motels clustered around interchanges. Kimball, originally known as Antelope, was renamed in 1885 in honor of Thomas L. Kimball, a prominent UP official.

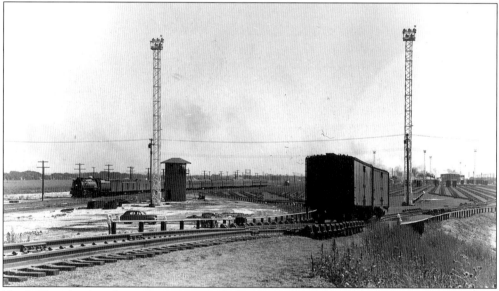

North Platte has long been synonymous with the Union Pacific. Unlike many railroad towns that have seen declining activity and employment, North Platte has only grown busier. About 2,600 worked for the UP here in 2002. The first hump yard, using gravity switching to speed classification of freight trains, is shown just after completion in 1948. Automatic retarders slowed cars rolling down the hump so they coupled onto the trains being assembled at a safe speed. Within 20 years a second yard was built for eastbound traffic, and a new diesel shop was under construction. The 2,850-acre complex is known as Bailey Yard, in honor of Edd H. Bailey, an up-from-the-ranks railroader who served as UP president from 1965 to 1971. In 1995 the Guinness Book of Records proclaimed it the world's largest railroad yard. (Arthur E. Stensvad, James J. Reisdorff collection.)

Three

DOWN AT THE DEPOT

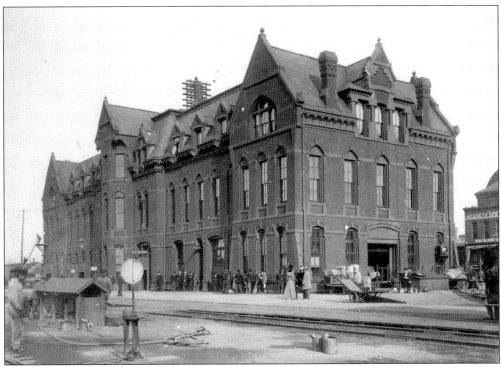

The 1881 Burlington & Missouri River depot at Lincoln was a formidable structure, reflecting not only the heavy volume of passenger traffic here but also housing the many functions needed to direct the road's operations across eastern Nebraska. It was modified in 1905–06 but was eventually torn down to make way for a new three-story depot and office building, completed in October 1927. The latter has been redeveloped as Lincoln Station, with a rental hall, restaurant, and antiques mall, although Amtrak still uses the north end. (Nebraska State Historical Society.)

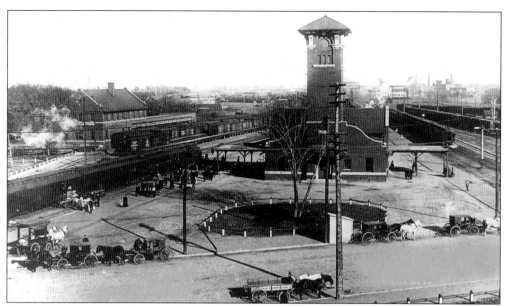

Fremont was one of the busiest rail centers in Nebraska outside of Omaha and Lincoln, enjoying at least two railroads since early 1869. In 1904, a new union passenger depot was completed, serving trains of the Chicago & North Western (left) and the Union Pacific (right). At far left is the C&NW's freight depot and office building. The latter still stands. However, the passenger depot was razed in stages, starting with the tower in the 1940s. What was left was replaced by a new office building in November 1985. The Burlington was a latecomer, reaching Fremont in January 1906. Its depots were a block to the south. (Dodge County Historical Society.)

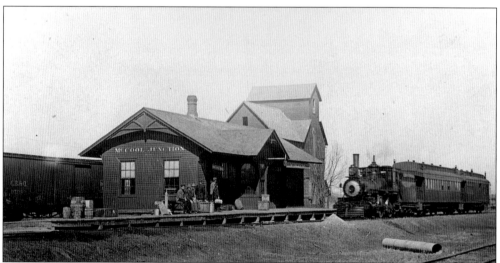

McCool Junction was the focal point of the wishbone-shaped Kansas City & Omaha Railway. The KC&O, built by the St. Joseph & Grand Island in 1886–1887, connected Stromsburg, Alma, and Fairbury. It came under Burlington control in the early 1900s. A two-car Burlington passenger train is headed south early in that period. The track south to Fairmont was abandoned in 1932, that going west to Lushton in 1955. The town's last rail link, south from York, lasted until 1984. The depot was moved to a new site in 1994 and is being restored by a private nonprofit group. (H. Roger Grant collection.)

A young Joe and Nettie Bowers, with an unidentified friend (left) pose on the Burlington depot platform at Wahoo in the early 1900s. As the local agent in Wahoo, Bowers came to symbolize the railroad during his 35 years here. The couple donated their home, in the former Burlington section house, and three acres purchased from the railroad to the Saunders County Historical Society in 1974. The gift was to help develop a historical display that included the depot. The grounds are now known as the Joe Bowers Memorial Historical Park. (Saunders County Historical Society.)

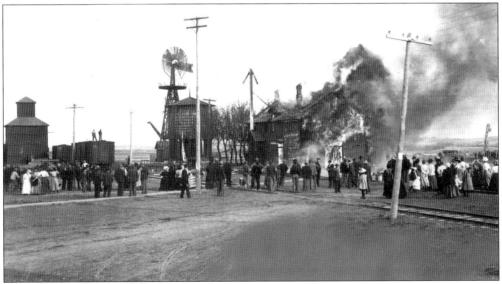

Railroads often provided living quarters in depots to their local agent and family. One hazard of living near the tracks was the danger of fire sparked by passing steam locomotives. The agent and family at Litchfield on the Burlington were temporarily homeless after the events of May 8, 1909. Derailing railroad cars could also damage or destroy trackside homes. And "depot moms" had to know where their children were whenever they heard a train approach. (Francis G. Gschwind collection.)

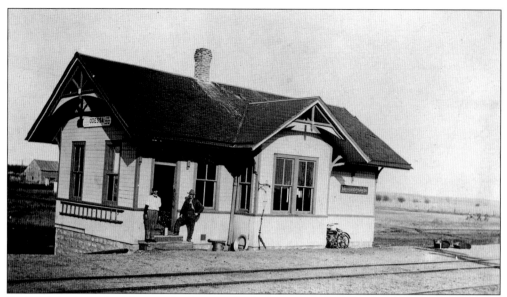

Railroads had standard designs for depots, which could be adjusted according to the size of the community. Odessa, on the Union Pacific main line west of Kearney, was one of the smallest examples of a standard "combination" depot, serving both freight and passengers. Other versions had larger freight rooms and passenger space. Some also had living quarters for the agent. After the Odessa depot was closed in 1972, a former agent moved it to Elm Creek to house her antiques business. (Nebraska State Historical Society.)

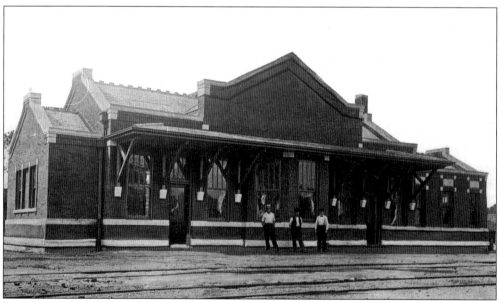

As communities prospered from rail connections, larger second-generation depots replaced the wooden originals at county seats and other important points. This one was erected in 1911 at Schuyler on the Union Pacific main line. It was demolished on January 7, 1980, after UP personnel moved into a smaller metal building put up nearby. A building of similar design served the UP and the Chicago, St. Paul, Minneapolis & Omaha in downtown Norfolk. (Nebraska State Historical Society.)

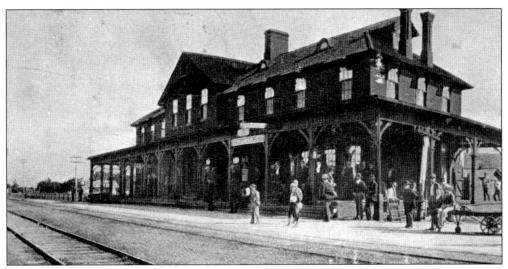

Fairfield became a major junction in the mid-1880s when the St. Joseph & Grand Island Railway began constructing its Kansas City & Omaha Railway in two directions, from the Fairfield junction, lines ran northeast to York and Stromsburg and southwest to Minden and Alma. A large depot and hotel was deemed necessary to serve the many travelers and railroaders expected. By the early 1900s, the KC&O had fallen into Burlington hands, becoming just another part of its branch-line network. Union Pacific, which got control of the StJ&GI, had little need for such a large facility here, but it survived until a spectacular fire on October 31, 1937. (James J. Reisdorff collection.)

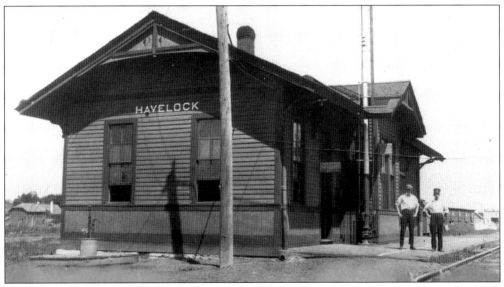

While the Burlington dominated Havelock's economy with its large shop payroll, the Rock Island had built through the south end of the village in 1890 and opened its own depot, shown here. The Burlington also had a standard, wooden, small-town depot here. Apparently, neither felt the need to try to outdo each other with construction of more impressive facilities. With Lincoln so close, Havelock was basically just a flagstop for passengers. The state made the Rock Island build another depot about a mile to the west to serve University Place, another suburb northeast of Lincoln. (James C. Seacrest collection, courtesy of James McKee.)

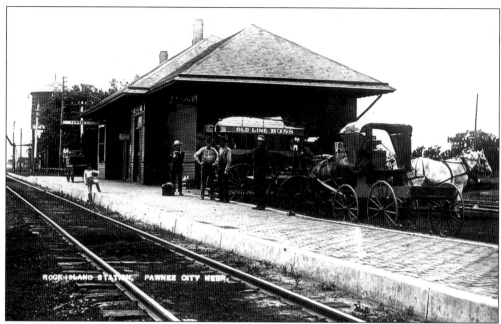

The Rock Island depot at Pawnee City was ready for the next train, complete with a "buss" for arriving travelers. Pawnee City was on the Rock Island's original 1887 main line through southeast Nebraska, although construction of a shorter route via Lincoln soon relegated it to secondary status. Freight service continued until January 1967. The Rock Island crossed over the Burlington on the west edge of town. The bridge there was once used for a lynching. (Nebraska State Historical Society.)

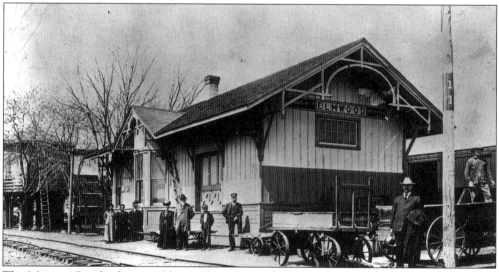

The Missouri Pacific depot at Elmwood was a standard structure like those at other towns on the branch to Lincoln from Union. The town was notable for being the home of author Bess Streeter Aldrich, whose works described life in a small town. Elmwood's last train came through on August 2, 1986, although the town is now a popular destination for those who use the MoPac East Trail out of Lincoln, built on the former rail right-of-way. (Nebraska State Historical Society.)

If not a real Franklin stove, it was at least a stove in the Burlington depot at Franklin. While larger depots had boilers and central heating, stoves were common at smaller facilities. They kept travelers warm on frigid nights as they waited for the first sound of their approaching train. The depot clock was another regular feature, ticking away the long hours. Some depots lacked the convenience of indoor plumbing—even into recent years. A few depot living quarters were fixed up by occupants while others remember them as primitive. (Nebraska State Historical Society.)

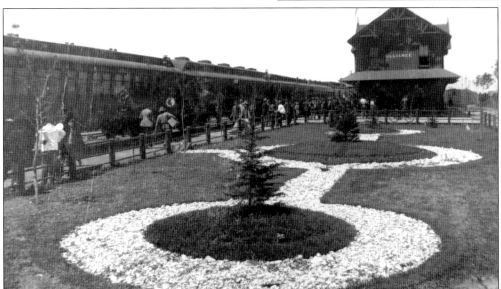

Depot parks, such as this one at Alliance, were found in many towns and were a source of pride for both the railroad and the community. Sometimes the town name was spelled out in large concrete letters. Because the only impression most travelers got of a town was what they saw from the train window, well-tended grounds were considered vital. In later years railroads couldn't spare employees for landscaping duty. These onetime showpieces fell into neglect or were appropriated for new uses—such as parking. (Alliance Knight Museum.)

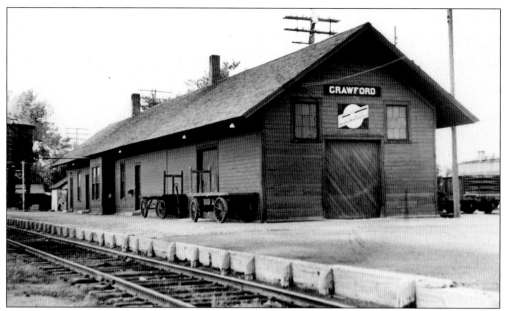

Crawford was an example of the rambling dark-red depots found along the Chicago & North Western in Nebraska. Distinguishing features included the nine-pane end windows and the C&NW herald, an added touch at some locations. Crawford was a competitive point, also being served by the Burlington. The latter would become the dominant railroad here, both for passenger travel and in total rail traffic. By the mid-1940s, the C&NW offered travelers only a motor train east to Chadron or west to Casper, Wyoming. It was discontinued in 1950. The Burlington had passenger service here until August 1969. (Joseph C. Hardy, James J. Reisdorff collection.)

Boxcar bodies or boxcar-like structures sometimes sufficed at towns considered too small for a regular depot. Denman was a station on the Union Pacific freight cutoff between Hastings and Gibbon completed in 1913. This simple depot served from 1916 until closing in the 1940s. This February 1916 view shows the agent is ready for business. There is a baggage truck for parcels and commercial telegraph service is available. (James J. Reisdorff collection.)

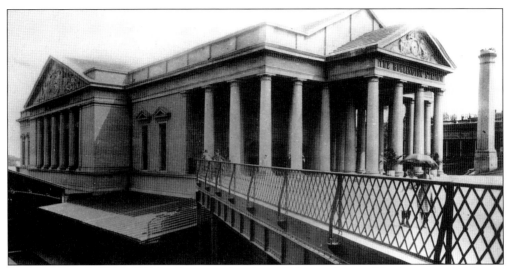

The Burlington Station in Omaha, completed in 1898, was designed by hometown architect Thomas R. Kimball in the Greek Revival style. In 1898, Omaha hosted a world's fair, the Trans-Mississippi International Exposition. The Burlington modernized and expanded the depot in 1930, transforming it into a Neoclassical structure to compete with the new Union Station being built to the north. The columns were removed, although 24 were later re-erected between the University of Nebraska Coliseum and Memorial Stadium in Lincoln. Amtrak vacated the Burlington depot in February 1974 for "temporary" trailers. A new use is still sought. (Nebraska State Historical Society.)

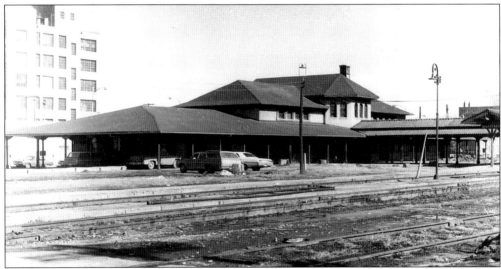

Another Thomas R. Kimball depot was built for the Burlington at Hastings in 1902. It included a restaurant and was long considered a community showpiece. By February 1971, when this photo was taken, passenger service had dwindled to just two pairs of trains. This would drop to one with the start of Amtrak on May 1, 1971. Burlington Northern moved out on April 1, 1984, but later considered redevelopment of the building for offices. Dutton-Lainson Corp. eventually bought the depot and transformed it in 2000–2001 into a showroom and retail store for its plumbing and kitchen fixtures lines. A new Amtrak waiting room was provided in the west end. (William F. Rapp.)

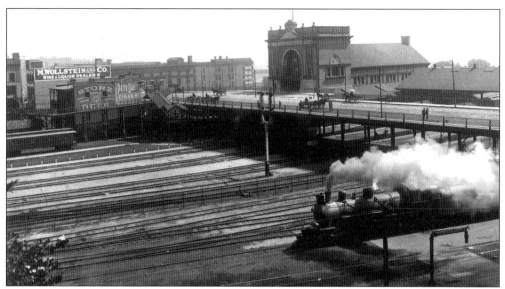

Omaha has long had two major depots. This 1905 view looks north toward Union Depot. It served the Union Pacific and most of the city's other railroads. The Burlington had its own depot off the south end of the Tenth Street viaduct to the right. One of its westbound trains is shown in the foreground. Omaha had a third passenger depot north of downtown at Fifteenth and Webster streets. By 1905, it served only the Chicago, St. Paul, Minneapolis & Omaha Railway, plus a Missouri Pacific local. (Union Pacific Museum.)

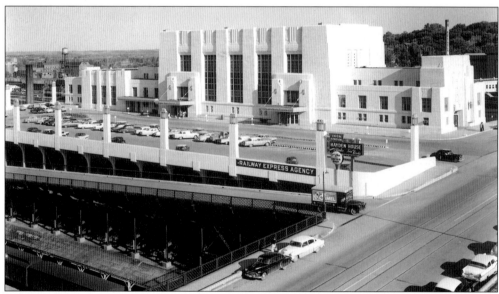

Omaha Union Station was still a major civic gateway in 1957. In addition to its owner Union Pacific, it also served the Chicago & North Western, the Milwaukee Road, the Rock Island, Missouri Pacific, and the Wabash. (Illinois Central exited in 1939.) However, declining rail passenger traffic made it an increasingly quiet place, especially during the day. In its last active year, only one train each way stopped here—in the middle of the night. Symbolic of changing travel patterns, the Hayden House restaurant moved to the airport. The UP gave the vacant depot to the city in 1973. It's now the Durham Western Heritage Museum. (Union Pacific Museum.)

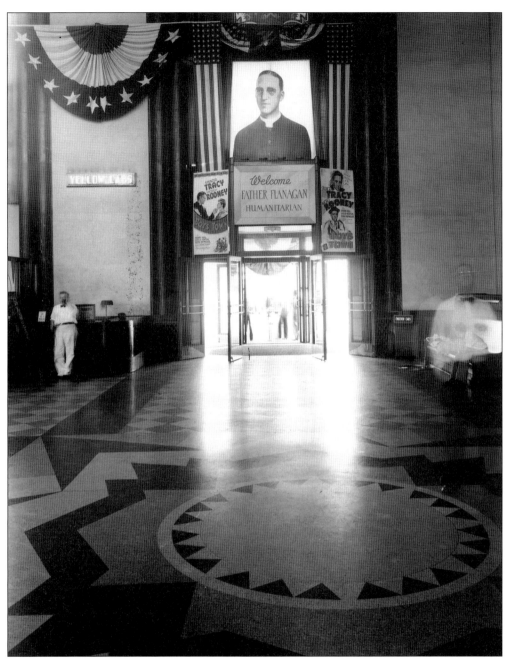

Omaha Union Station was decorated for visitors arriving for the world premiere of *Boys Town*. The 1938 film starring Mickey Rooney and Spencer Tracy told the story of Father Flanagan and the world-famous youth home he founded. Union Pacific itself was the star in the 1939 Cecil B. DeMille epic about the construction of the first transcontinental railroad. The premiere of *Union Pacific* brought a trainload of celebrities from Hollywood and the lively "Golden Spike Days" celebration. (Union Pacific Museum.)

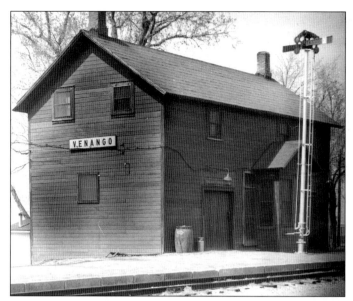

Venango was the last stop in Nebraska on the Burlington's Hi-Line from Holdrege to Sterling, Colorado. Its depot was a typical example of the two-story saltbox design widely used by the Burlington in Nebraska and other states west of the Missouri River. The waiting room, office, and freight room were on the ground floor. The agent's living quarters were upstairs. Some depots had a one-story extension to provide additional room for merchandise shipments. (William F. Rapp.)

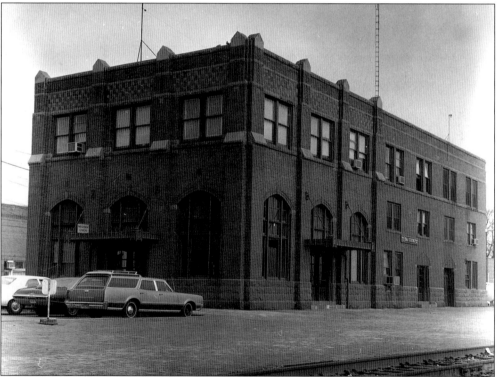

McCook has long been the center of Burlington operations in southwest Nebraska. After years of civic pleading for a new depot, the railroad finally opened this three-story structure in April 1926. In addition to serving passengers, it also had space for McCook Division officials and train dispatchers. Into these offices came reports of the unfolding flood disaster along the Republican River in May 1935. In recent years, many of the official functions have been moved elsewhere, but the depot still houses some Burlington Northern & Santa Fe offices and is an unstaffed Amtrak stop. (William F. Rapp.)

46

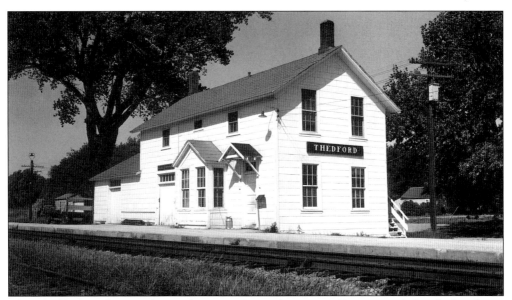

The Thedford Burlington depot, shown on September 11, 1966, was re-sided with shingles in later years, a modification made on some CB&Q depots. The railroad also extensively rebuilt many depots in the 1940s, removing the now-surplus freight room and the living quarters upstairs. This usually left a squat, nondescript building. In the mid-1950s, the railroad enacted another visible change: the replacement of the dark "Burlington red" with white as the standard structure color. (Francis G. Gschwind.)

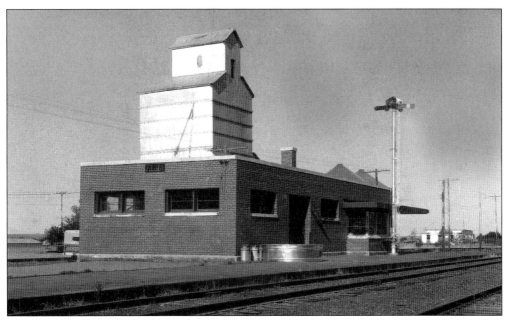

This modern depot was built for the Burlington at Alma by the federal government as part of the track relocation necessitated by Harlan County Dam. Operations through Alma were shifted to the new line on May 1, 1950, but the depot had a relatively short career. It was closed in May 1971, when a mobile agency began serving the area. It was torn down in January 1990. (William F. Rapp.)

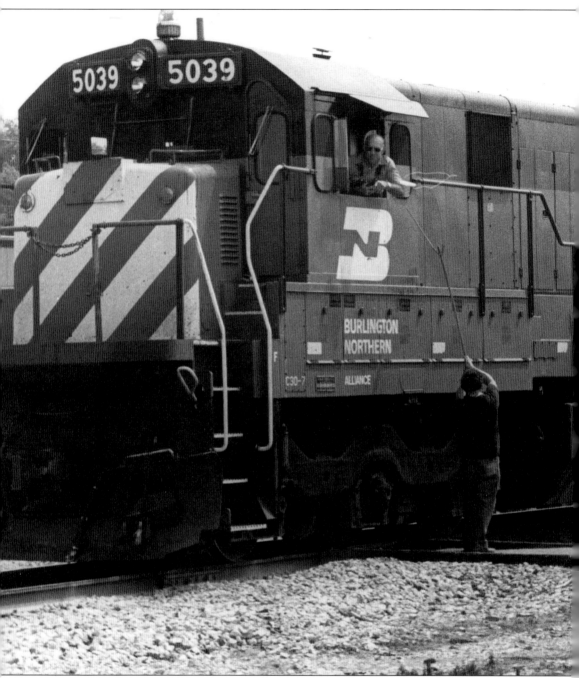

A common sight in front of depots was of train orders being handed off on the fly to passing train crews. Sometimes the operator had to stand close to the track to deliver them, while other locations had special racks where orders were fitted. This scene occurred on the Burlington Northern at Ashland on July 2, 1985. Train orders, called "flimsies" because they were usually written on tissue-like paper, were operating instructions relayed from the dispatcher. Failure to follow them to the letter could be disastrous. In later years, train orders were replaced by track warrants, given to crews through computer and phone messages. (Charles W. Bohi.)

Four

STREAMLINERS
AND FREIGHTS

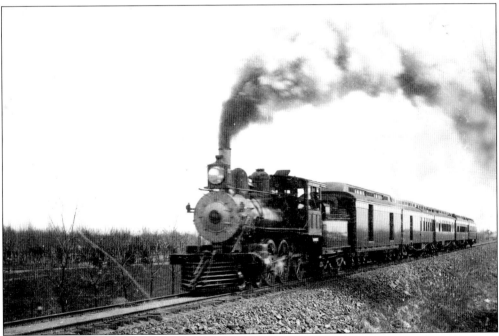

An early Burlington passenger train rolls along behind a 4-6-0 near McCook in the early 1900s. Wood cars soon gave way to steel, and steam locomotives became bigger and faster. The 1930s introduced streamlined trains and diesel power. The stainless steel used on the first Zephyrs has proven to be one of the most enduring and functional industrial designs. Another 1930s improvement was air conditioning, making summer travel pleasurable and keeping cinders and soot out of the cars—and off the passengers. (High Plains Historical Society.)

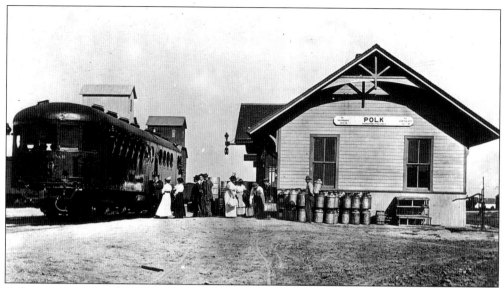

A forerunner of the diesel was the McKeen motor car, noted for its porthole windows, sharp prow, and rounded rear. The cars were developed in 1905 by William R. McKeen, Union Pacific's superintendent of motive power and machinery. He formed his own company in 1908 to produce them in Omaha. UP was one of McKeen's best customers. Here an eastbound McKeen is at Polk on the Stromsburg Branch. Electro-Motive Corp. came to dominate the business, relegating the McKeen Motor Car Co. to history by 1920. Its electric transmissions had proven superior to McKeen's mechanical drive. (Nebraska State Historical Society.)

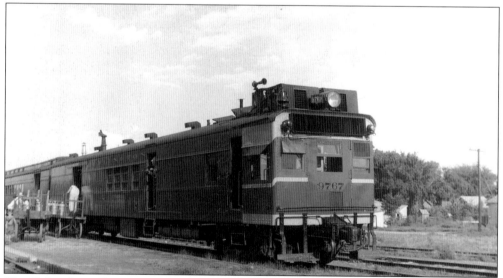

"Doodlebugs" cost less to operate than steam trains and thus prolonged the life of passenger service on many secondary lines. Some, such as Burlington No. 9767, were powerful enough to pull a trailer. Here, cream shipments are transferred during a stop in Superior in June 1955. As train No. 15, the motor train was en route from Wymore to Oxford and would return as No. 16 the next morning. This run was discontinued on March 2, 1958. (Richard L. Schmeling.)

50

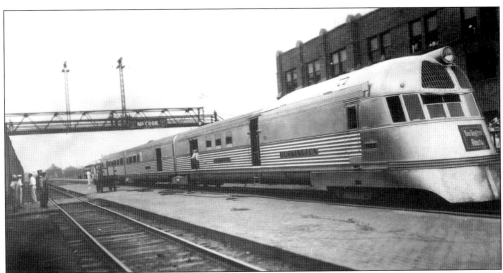

The Burlington's Pioneer Zephyr was America's first diesel-powered streamlined train. It captivated the nation in May 1934, with its nonstop dash from Denver to Chicago. It even starred in a movie, the first *Silver Streak*. Here, it is shown as it passes through McCook. Its first regular assignment was between Lincoln, Omaha, and Kansas City, but it ran through McCook in the summer and fall of 1936 as one of the Advance Denver Zephyrs. Between 1942 and 1948, it was used in local service between Lincoln and McCook. The Pioneer was retired in 1960 and donated to Chicago's Museum of Science and Industry. (High Plains Historical Society.)

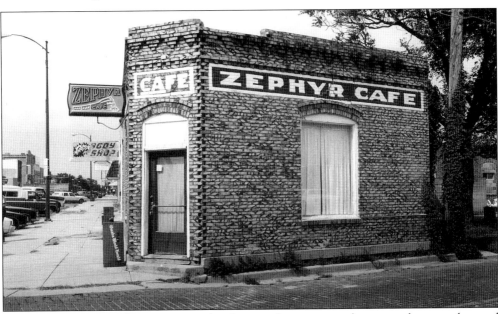

There was always a café or two near the depot in larger towns that catered to travelers and railroaders. This is the appropriately named Zephyr Café in Holdrege. The newspaper rack was stocked with the *Omaha World-Herald*, which in years past made extensive use of passenger trains to become a statewide newspaper. Going down to the depot to see the new streamlined Zephyrs became a popular, inexpensive pastime at Holdrege and other towns along the Burlington main line in the 1930s.

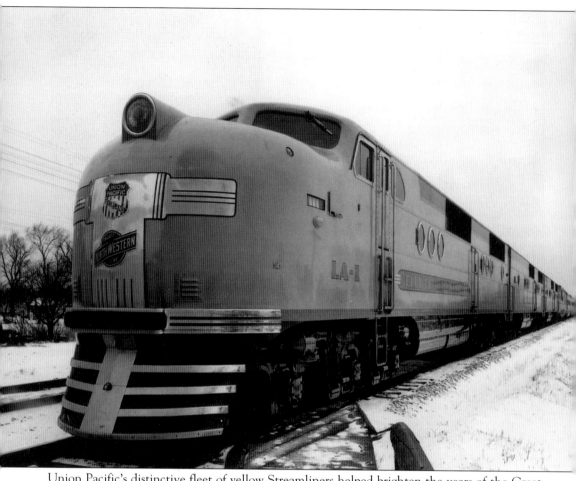

Union Pacific's distinctive fleet of yellow Streamliners helped brighten the years of the Great Depression, starting with delivery of the first two in 1934. They began regular service between Kansas City and Salina, Kansas, and between Chicago and Portland, Oregon, in 1935. The first City of Los Angeles, traveling between Chicago and Los Angeles, debuted May 15, 1936. The second City of Los Angeles consist (pictured here) joined it in December 1937, doubling the frequency of operation to every third day. Daily service didn't come until 1947. The bulbous nose of this diesel unit still reflects the customized styling of the 1930s streamlined trains. The Chicago & North Western operated the Chicago-Omaha portion of the run. (Nebraska State Historical Society.)

The doodlebug became a mini-streamliner with the Missouri Pacific's "Eaglet," built in 1942 to provide a Lincoln connection for its Missouri River Eagle, a full-dress streamliner between Omaha, Kansas City, and St. Louis. It made two round trips a day to Union where passengers changed to the big Eagle. The Eaglet, after being replaced by a bus in July 1954, was reassigned to service between Helena and McGehee, Arkansas. It was scrapped in the early 1960s. (Nebraska State Historical Society.)

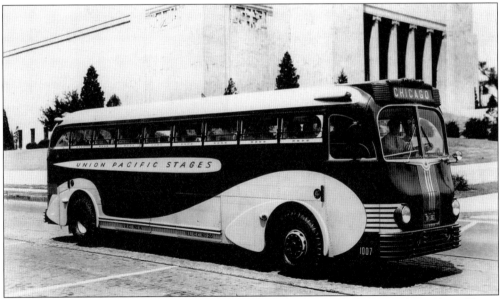

Railroads met the challenge of bus competition by getting into the business themselves. Union Pacific operated Union Pacific Stages and Interstate Transit Lines, the latter owned jointly with the Chicago & North Western. One of its buses is shown in front of Omaha's Joslyn Art Museum. Among Nebraska railroads, the Burlington and the Missouri Pacific also had large bus subsidiaries. Growing pessimism about short-haul passenger traffic caused railroads to exit the business in the postwar years. Union Pacific sold a large minority stake in its two bus subsidiaries to Greyhound in 1943 and then the rest, also to Greyhound, in 1952. (Nebraska State Historical Society.)

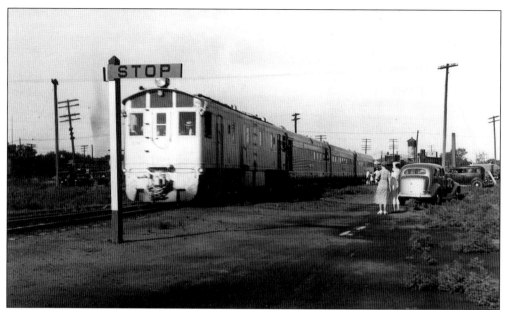

The Rock Island joined the streamliner bandwagon in 1937, when it acquired its first six stainless steel Rocket train sets. One has drawn a crowd at Fairbury on July 11, 1937, as it heads west with a special train of Elks bound for their national convention in Denver. An Electro-Motive Corp. demonstrator diesel was used instead of the striking red, maroon, and silver model intended for Rocket service. Fairbury wouldn't be on a regular Rocket route until November 1939, when the Rocky Mountain Rocket was inaugurated between Chicago and Colorado. (Fairbury Museum.)

Rock Island officials could inspect their domain in this automobile, fitted with flanged rubber tires for rail travel. It's shown at Fairbury, headquarters of the Western Division, in April 1938. Subsequent improvements included equipping inspection autos with retractable steel wheels, permitting travel by rail or road with equal facility. The hi-rail concept was later expanded to trucks used by maintenance personnel, replacing the familiar "putt-putt" track speeders. (Fairbury Museum.)

54

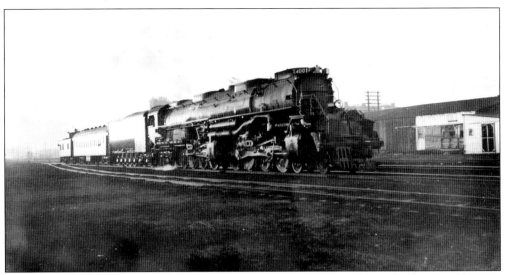

The biggest steam locomotive of all was Union Pacific's Big Boy. The nickname came from an unknown workman who chalked it on an unpainted boiler at American Locomotive Co. in Schenectady, New York. One of the first, No. 4001, heads west at North Platte in 1941. A total of 25 4-8-8-4s, as classified by wheel arrangement, served UP until 1959. Aside from delivery, they were rarely seen in Nebraska and instead spent their careers between Cheyenne, Wyoming, and Ogden, Utah, especially over Sherman Hill between Cheyenne and Laramie. Eight have been preserved. (Arthur E. Stensvad, James J. Reisdorff collection.)

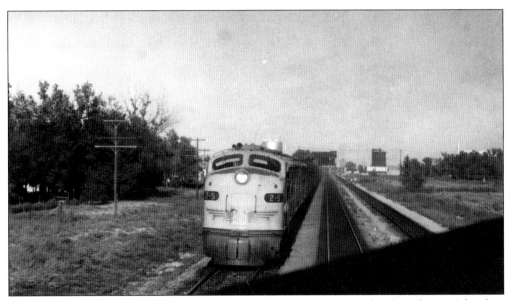

The Union Pacific main line, with its two tracks across the state, has long been Nebraska's busiest rail route. Here, an eastbound meets the second section of No. 5, a mail and express train, somewhere in western Nebraska in the 1950s. Passenger service ended on May 1, 1971, but the main line today has more trains than ever. Much of the growth has been in unit coal trains, which UP began handling in earnest in 1984. The main line is now three tracks wide from North Platte to a key junction east of Gibbon. This segment now sees 120 or more trains every 24 hours. (James J. Reisdorff collection.)

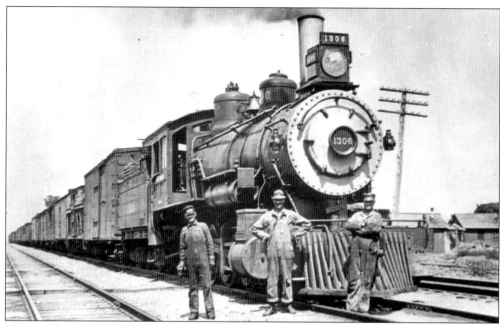

This proud crew of Union Pacific local freight No. 75 poses for a photo at Chapman. They had come off the Stromsburg Branch at Central City, en route to Grand Island to complete their run. Engine 1306 was later renumbered No. 105. As such, it and two other 100-class 2-8-0s served the Kearney-Stapleton branch until 1950. (Francis G. Gschwind collection.)

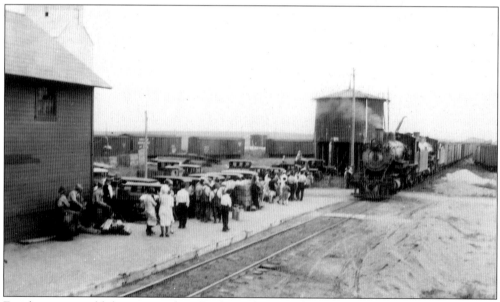

Freight trains could draw a crowd to the depot for special events. A Burlington freight arrives at Elsie on the Hi-Line in southwest Nebraska with the Perkins County Wheat Special, an agricultural promotion. Perkins County was named for Charles E. Perkins, president of the Burlington at the time the county was organized in the 1880s. (Elsie was named for Perkins' daughter.) The Hi-Line name was strongly associated with the territory along this long railroad line. Even today, it appears in several business names. (Nebraska State Historical Society.)

This is the view the engineer got as his train passed between two others in the Union Pacific yard at North Platte. The refrigerator cars ("reefers") at left belonged to Pacific Fruit Express, a joint venture by the Union Pacific and the Southern Pacific to transport perishables. Massive docks were needed at strategic intermediate points for PFE employees to restock the reefers with ice. Railroads also had extensive ice-harvesting operations on local lakes in winter. Mechanical refrigeration later replaced iced reefers. Trucks have proved tough competitors for this business too. (James J. Reisdorff collection.)

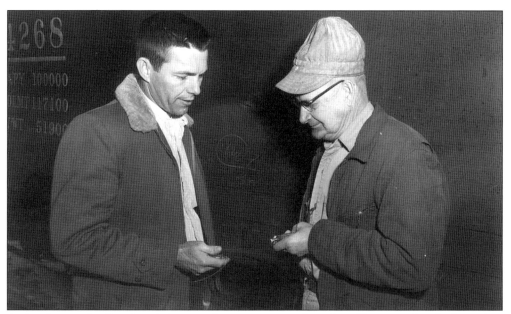

A time-honored railroad tradition was the comparison of watches. Crew members had to select precise timepieces from an approved list and then have them regularly inspected. They would check them against a standard clock and with each other to make sure all had the correct time. This scene with conductor L.E. Dickerson (right) and station agent K.L. Thomas was at Hebron in 1959, on a Rock Island branch where such precision probably wasn't needed. But a timekeeping error could lead to deadly collisions on busier routes. Later, a major policy change allowed wristwatches in addition to pocket watches. (James Denney, James J. Reisdorff collection.)

Nebraska isn't considered a major petroleum state, but Falls City and Richardson County in the southeast corner enjoyed an oil boom in 1939, when the state's first producing well was brought in. A Burlington freight train passes a derrick west of Falls City during those heady years. Loading racks filled tank cars and some refining was done here and at nearby Salem. During the postwar period, the focus of the state's oil and gas industry shifted to southwest Nebraska and the Panhandle, although some production continued in Richardson County. (Nebraska State Historical Society.)

Pooling the motive power of different railroads became common in the diesel era. However, steam locomotives were less likely to venture off their home rails. But surges in traffic sometimes prompted railroads to borrow, and occasionally buy, steamers from other roads. This leased Santa Fe 2-8-4 was heading a westbound Union Pacific freight train near North Platte in October 1952. (Arthur E. Stensvad, James J. Reisdorff collection.)

Five

LANDMARKS
AND EVENTS

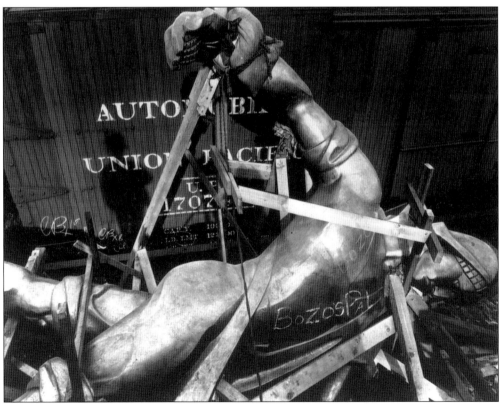

Perhaps the most unusual rail shipment ever to arrive in Lincoln was *The Sower*, a 19-foot, 19,000-pound bronze sculpture that would top the new Nebraska State Capitol. It arrived in Lincoln on the Union Pacific on April 12, 1930, nine days after leaving the foundry in Long Island City, New York. It was taken up on the temporary track laid down H Street, which was used to bring construction materials to the site. The chalkmarking of "Bozo's Pal" possibly relates to Bozo Texino, a legendary freight car graffiti artist whose moniker was somewhat akin to "Kilroy Was Here." (Nebraska State Historical Society.)

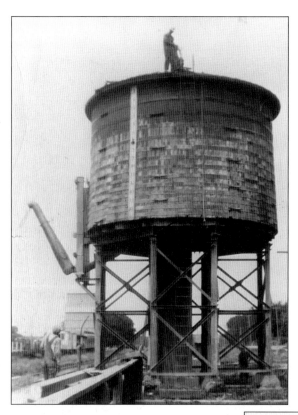

Steam locomotives used lots of water. The tanks needed to replenish their supply were a frequent and distinctive feature of the trackside scene. This one was on the Chicago & North Western at Bruno. They even brought the expressions "tank town" and "jerkwater town" into the popular vocabulary. Well-water was usually pumped into the tank by a small engine or windmill, or municipal water was purchased. Some locations required treatment facilities to make the water suitable for boilers. Dieselization eliminated the need to maintain these installations, another economic benefit over steam power. (James J. Reisdorff collection.)

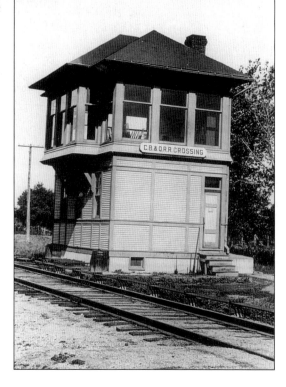

Towers protected many crossings of railroad lines, such as this one at Columbus where a Burlington branch intersected the Union Pacific main line. The large levers upstairs were connected to switches and signals via rods, requiring some physical strength to change their positions. Automatic interlocking signals eliminated the need for manned towers. This one was closed in the early 1950s, although one ran in Lincoln into the 1990s. The last one outstate was at Grand Island, which served until 1983. (James J. Reisdorff collection.)

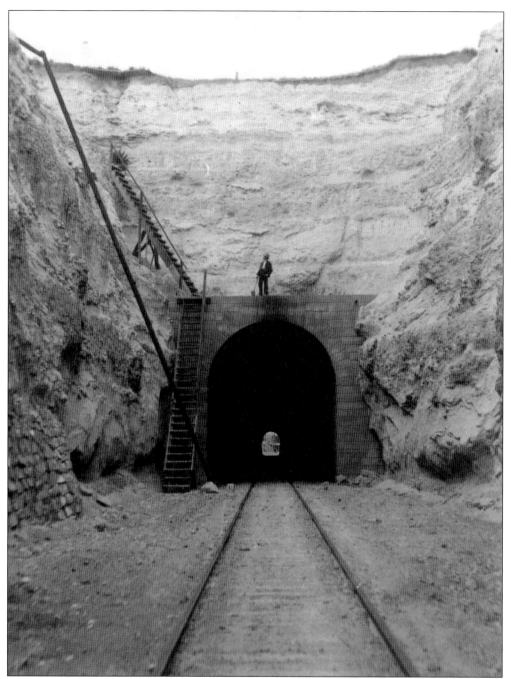

Nebraska's only railroad tunnel was located in the northern Panhandle where the Burlington cut through the rugged Pine Ridge between Hemingford and Crawford. The 713-foot bore was sometimes called the Belmont Tunnel, after the small village near the summit of Crawford Hill. This view is from the early 1920s, before the tunnel received modern concrete portals. The coal boom of the 1970s made it a bottleneck, so Burlington Northern simply bypassed it with two new tracks to the west in 1982. The tunnel remains as part of a company access road. (Alliance Knight Museum.)

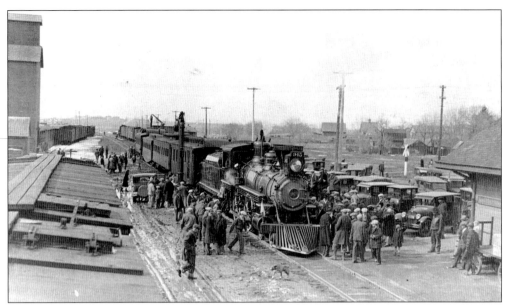

By the 1920s, the pioneer era was 40 to 60 years in the past in most areas of Nebraska. Union Pacific assembled a train of early equipment for display at special events, such as the opening of new depots. Here, it stops at Stromsburg on February 21, 1927. The 4-4-0 locomotive was once the mainstay of everyday operation. Now it was confined to a dwindling number of steam-powered locals. About 800 people gathered to marvel at the contrast between steam trains of the old days and those of the modern era. But in just seven years, the diesel locomotive and the streamliner would make even the most modern equipment of 1927 seem obsolete. (James J. Reisdorff collection.)

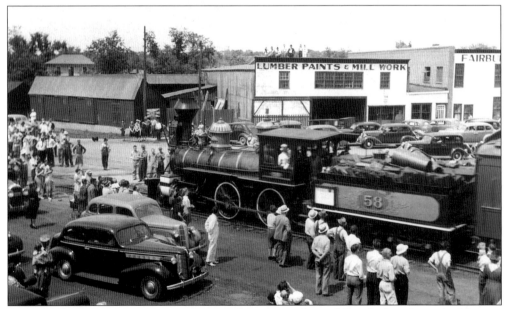

A similar display train, using an early steam locomotive from a Nevada short line, the Virginia & Truckee, was assembled in 1939 to promote Cecil B. DeMille's epic *Union Pacific*. Here, the train makes a stop in Fairbury during May of that year. (Fairbury Museum.)

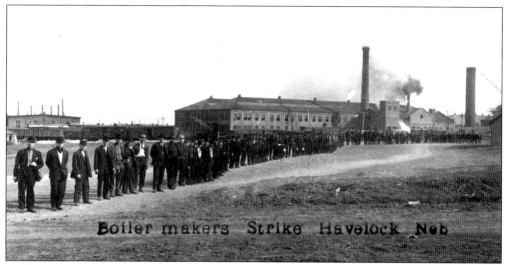

Railroad shops, like many industrial workplaces, saw their share of strikes and other disputes. This photo shows a walkout by boilermakers at the Burlington's shops in Havelock, northeast of Lincoln, in 1922, as part of a nationwide strike by rail shopcraft unions. About 950 people worked at Havelock at the time. The strike brought turmoil and violence here and to railroad towns across the nation as companies hired replacement workers. Some strikers did return, but many moved on, to other railroad shops or different lines of work. Bitterness and hard feelings over the strike lingered into the 1960s in many railroad towns. (Nebraska State Historical Society.)

Veteran Chicago & North Western employees and their wives gather for a dinner at the Elks Club in Chadron in 1950. Some of them could have remembered the first years of the railroad era in northwest Nebraska. All labored through extremes in weather and met the challenges of an occupation that could be among the most dangerous. All shared the brotherhood of being called railroad men. (Dawes County Historical Society.)

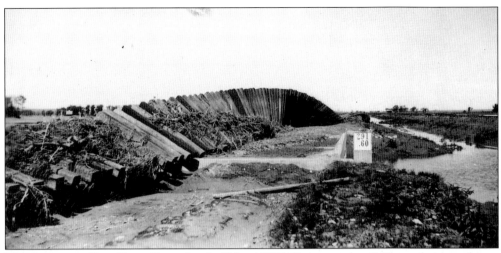

The devastating Republican River flood of May 1935 killed more than 100 people in southwest Nebraska and left miles of Burlington track—such as this in Red Willow County (McCook)—unusable. It also came between the two driest years of the Dust Bowl, 1934 and 1936. By May 29, Burlington forces were just getting back to normal after repairing the flood-damaged Frenchman River bridge west of Culbertson when catastrophic destruction and loss of life struck the valley again. Another flood on June 17 set work back five days, but the first passenger train from the east, No. 5, reached McCook on June 22. The first through train from Denver, the Aristocrat, No. 6, arrived at 2 a.m. June 24. (Nebraska State Historical Society.)

Tough-as-nails William Jeffers reigned over the Union Pacific from October 1937 until February 1946. The North Platte native had started with the UP as a call boy calling—and finding—crewmen for duty. He served the nation during World War II by heading up the federal program to produce synthetic rubber after natural supplies in Southeast Asia were cut off. During his years leading UP, the road acquired its largest steam locomotives and expanded the Streamliner fleet. His hometown renamed a major street in his honor. (Union Pacific Museum.)

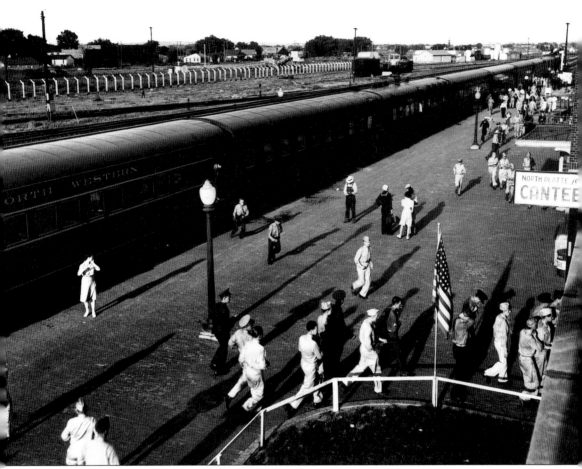

Soldiers rush for a brief snack at the World War II Canteen run by volunteers in the Union Pacific depot at North Platte. It began December 25, 1941, and ran until April 1, 1946, serving more than 6 million military personnel. It wasn't the only depot canteen—one also ran at McCook, among others—but it has come to symbolize all such homefront hospitality efforts. An estimated 55,000 volunteers from 125 communities in western Nebraska and eastern Colorado provided snacks, refreshments, magazines, cigarettes, and chewing gum to those on every troop train, despite World War II's shortages and rationing. Troop trains could be expected at any time on the busy UP main line, one of the major routes for such traffic. There were always cakes because every day was a birthday for someone among the 3,000 to 5,000 troops who stopped here daily. Toward the end of the war, as many as 8,000 were served a day. The hospitality was long remembered by those who received it and by those who provided it. Even today, the North Platte newspaper publishes occasional letters from veterans thanking the community. Unfortunately, the depot was torn down in November 1973. A minipark commemorating the Canteen marks the site now. Several books have been written about it, including a 2002 best-seller, *Once Upon a Town* by syndicated columnist Bob Greene. (Union Pacific Museum.)

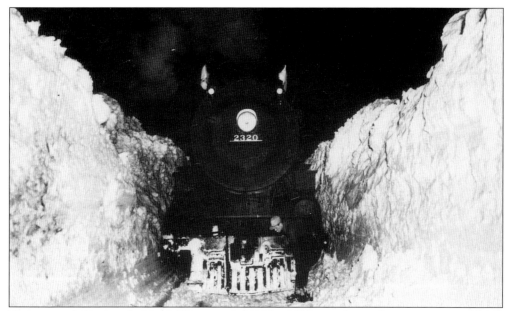

This view of Chicago & North Western, 2-8-2 No. 2320, caught in the epic winter of 1949 symbolizes the hardships endured by many Nebraskans, especially those in the northern portion of the state. Some areas hadn't completely dug out from a November 1948 storm when a seemingly endless series of blizzards raged over January and February 1949. Some branches didn't see regular trains for weeks as railroaders struggled—and even died—trying to reopen lines still vital for everyday transportation of food, fuel, and the mail. Similar battles were taking place in Colorado, Wyoming, and other Western states. (Dawes County Historical Society.)

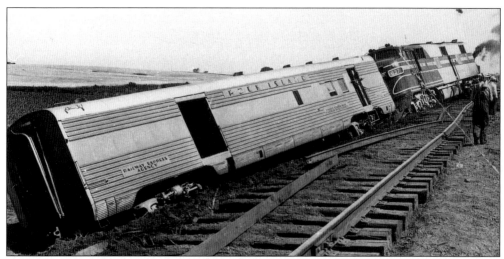

One of the most famous train wrecks in Nebraska came on June 25, 1954, when the Rock Island's Rocky Mountain Rocket, en route from Denver and Colorado Springs to Chicago, derailed north of Hallam. Even though most of the cars left the rails, no one was killed. The accident was blamed on a pinion gear that locked up on one of the diesel power trucks. Such events usually drew large crowds, keeping railroad security personnel busy keeping the curious out of the way. Other derailments in Nebraska history did involve passenger fatalities, even into the Amtrak era in 1976. (James J. Reisdorff collection.)

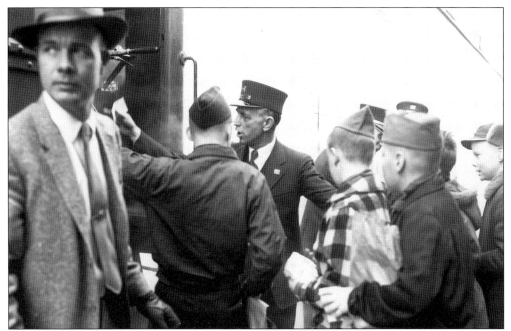

Boy Scouts board a Burlington special train at David City on January 29, 1955. The regular motor train on this branch was gone, but the Burlington was still aggressively seeking group passenger business, including Scout trips, sporting events specials, and steam excursions. These trips were still remembered fondly by those who rode. For some it was their first—and only—train ride. By 1965, new management abandoned this business and retired the large fleet of older coaches needed to handle it. (*The Banner-Press*, James J. Reisdorff collection.)

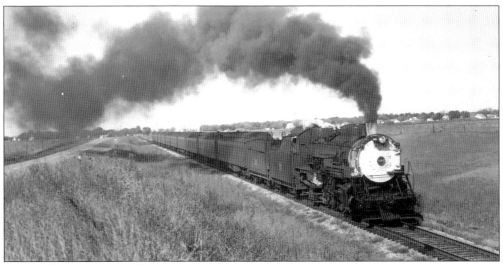

During the early 1960s, the Burlington operated excursions across much of its system, aimed primarily at giving schoolchildren their first—and probably only—chance to ride behind a steam locomotive. This special train, shown east of Litchfield on October 28, 1963, was taking passengers from Broken Bow and Ansley on a round-trip to Ravenna. The CB&Q ended steam excursions in 1966, although this locomotive, 2-8-2 No. 4960, eventually ended up on the Grand Canyon Railway. (Francis G. Gschwind.)

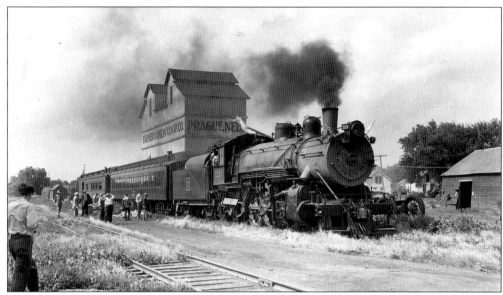

The year-old Camerail Club of Omaha had its first excursion on July 15, 1950. An extra coach was added to the regular Burlington mixed train that made a round trip to Prague from Gibson Yard in South Omaha. At Prague, passengers would help turn the locomotive on the turntable at "end of track." It was the first of many enjoyable outings that Camerail members and friends would have over the next 52 years. In the early 1950s, there were still numerous opportunities to ride behind steam on regularly scheduled mixed trains like this. (William W. Kratville.)

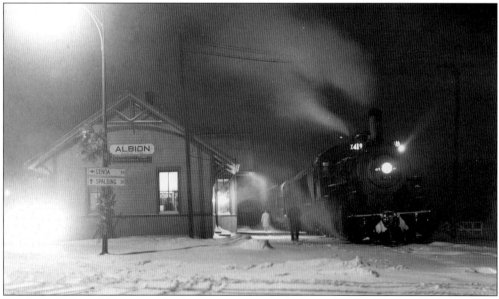

Omaha's Tribe of Yessir made a goodwill trip to Albion on December 12, 1951. The handshaking is done and the passengers have settled back aboard the warm coaches for the trip down the Union Pacific branch line to Columbus. There, a larger locomotive will take over for a high-speed return to Omaha on the main line. The 419 was one of the 400-class 2-8-0s that were standard power on UP branch lines in Nebraska and Kansas. Several have been preserved in parks and museums. (William W. Kratville.)

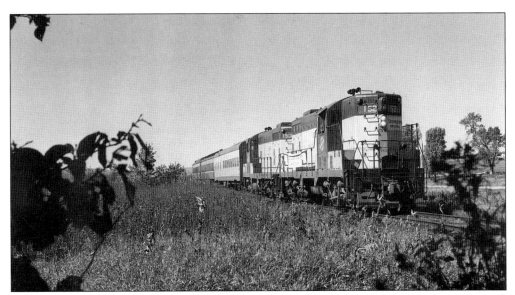

Several major political candidates, including Dwight Eisenhower and Robert F. Kennedy, took to the rails to reach Nebraska voters. One of the lesser-known whistlestop campaign trains was chartered by U.S. Rep. Glenn Cunningham of Omaha during his successful 1968 re-election bid. On October 6, the train slowly made its way between Oakland and Craig on the Chicago & North Western. This track was later abandoned, as was part of the route he used a week later on a similar "rare mileage" swing through the southern part of his district via the Missouri Pacific. (Thomas O. Dutch.)

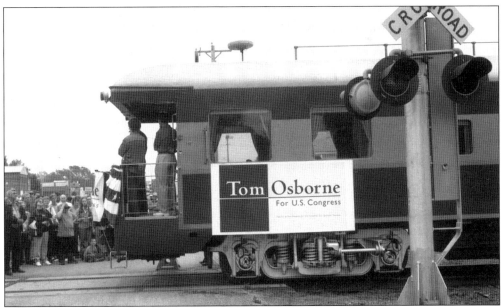

After a 28-year absence, a campaign train rolled again in Nebraska on August 20, 2000. Tom Osborne, seeking the 3rd District U.S. House seat, speaks to a crowd at Platte Center as he makes his way from Norfolk to Columbus on a Nebraska Central special. Some were no doubt drawn by Osborne's popularity as the former head coach of the University of Nebraska's national championship football team. His quest for victory at the ballot box would be successful too.

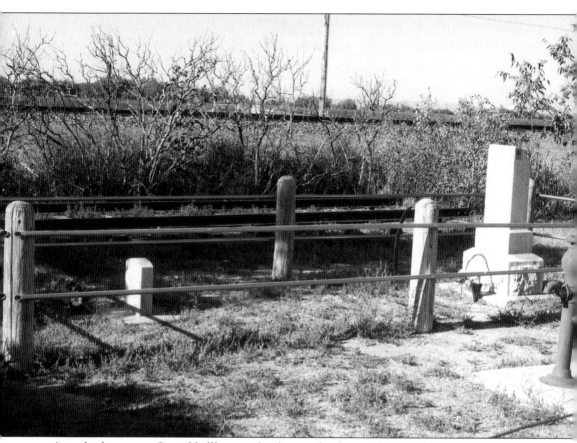

A trackside grave at Scottsbluff honors the thousands who perished on the westward trek before the railroad. One was Rebecca Winters, who died along the Mormon Trail in 1852. While many graves were unmarked, a wagon wheel rim was half buried at the site. The trail moved farther south and the grave was forgotten until Burlington surveyors pushed their way up the North Platte Valley in 1899. After practically stumbling over it, engineers suspected it may have been a Mormon pioneer grave and contacted a Salt Lake City newspaper. Meanwhile, they adjusted the survey to miss the site and put up a fence. Family members later supplied a granite monument. For safety reasons, her remains were reburied farther from the track on October 14, 1995, in a faithful reconstruction of the original grave site as seen five years later. The railroad still calls its nearby passing sidetrack "Winters." (James L. Ehernberger.)

The way west was often marked by a trail of blood as white and native cultures clashed. A series of raids had struck the Platte and Little Blue valleys in 1864, including the "Plum Creek Massacre" in the bluffs near today's Lexington. The coming of the railroad greatly increased the Army's mobility but didn't immediately eliminate attacks. A Union Pacific freight speeds west from Lexington on June 15, 1985, past a historical marker in the trees to the left that describes how another train crew met its end there on August 7, 1867, during an attack by Southern Cheyenne braves led by Chief Turkey Leg. A westbound UP freight train was wrecked, as was a handcar with a crew which preceded it. Three railroad employees were killed and two others injured. One track worker was scalped alive and the freight cars were looted. A highly exaggerated version of the incident was later portrayed in the 1939 movie *Union Pacific*. The town of Plum Creek changed its name to Lexington in 1889 to commemorate the Battle of Lexington in the Revolutionary War.

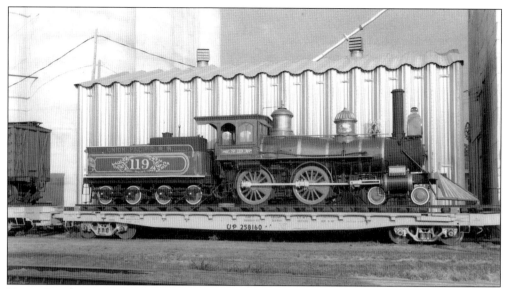

Union Pacific commemorated 1969's Golden Spike centennial by assembling an exhibition train of vintage equipment and sending it on a system tour. Two ex-Virgina & Truckee 4-4-0s were modified to resemble the Central Pacific's Jupiter and UP's No. 119, which met head-to-head at Promontory, Utah Territory, on May 10, 1869. The centennial train is shown at Osceola, Nebraska. Full-scale operating replicas were later constructed for the Golden Spike National Historic Site at Promontory. (Forrest H. Bahm.)

The Chicago & North Western hadn't run passenger trains to Chadron since July 1958, but it drew people back to the track in 1985 with a series of centennial excursions. Chadron had been a major operating center for the C&NW from its founding in 1885. One of the centennial trips is shown heading east from Chadron through the scenic Pine Ridge country. Similar excursions were operated out of other towns along the C&NW in northwest Nebraska that were also celebrating their 100th year. (Robert Eddy.)

Six
STEAM TO DIESEL

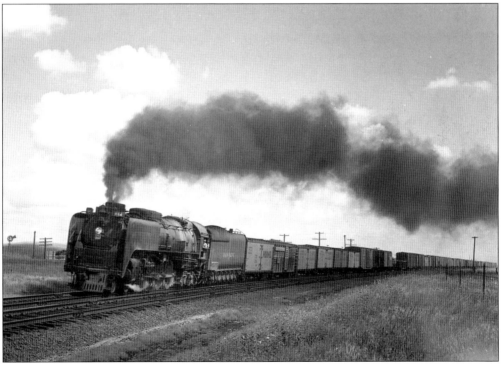

On August 18, 1957, Union Pacific 4-8-4 No. 844, shown here heading a westbound freight east of Brady, was just another steam locomotive, albeit the road's newest. However, UP would retain it for special service after regular steam use ended in 1959. It has powered numerous excursions and special trains, showing the UP flag at world's fairs, political conventions, and other commemorative events. It was joined in heritage service in 1981 by restored Challenger 4-6-6-4 No. 3985. (Francis G. Gschwind.)

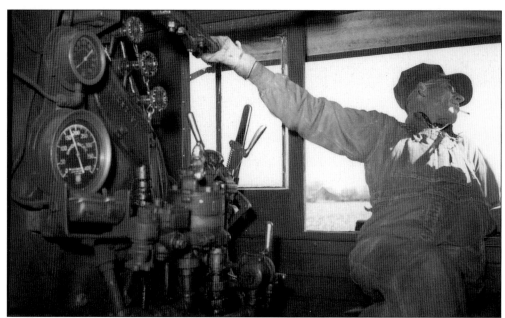

Union Pacific engineer Carl Anderson looks back out of the cab of 2-8-0 No. 407 as local freight No. 76 switches in Shelby in May 1949. Young railfans were often befriended by railroad men who would invite them up into the cab. While rides were forbidden by operating rules, such favors were sometimes extended on the branch lines, creating memories that lasted a lifetime. Some of these boys eventually went railroading themselves, despite admonitions from the "old heads" to just keep it as a hobby. (Forrest H. Bahm.)

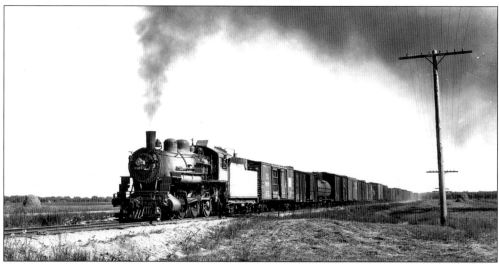

The R-1 4-6-0 was the Chicago & North Western's largest single class of steam locomotives, totaling 325 members. They were used in all manner of freight, passenger, and switching service. Some Nebraska branch lines could not accommodate anything heavier than an R-1. Here No. 1124 is heading west from O'Neill with a local freight train on September 4, 1950. Three of the class were saved. One, No. 1385, owned by Mid-Continent Railway Museum in North Freedom, Wisconsin, was borrowed by the C&NW for goodwill trips over many of its lines in the mid-1980s, coming as close to Nebraska as Council Bluffs, Iowa. (William W. Kratville.)

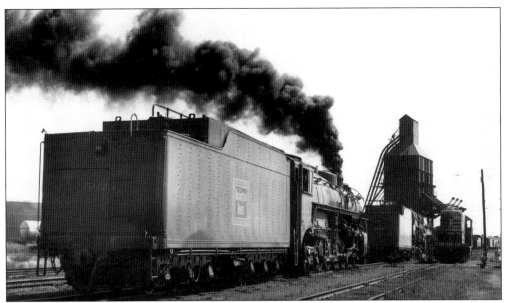

By July 1954, the steam era was slipping away at the Burlington engine terminal in Lincoln. The 5629, a 4-8-4, is pouring out smoke. It was one of the last steam locomotives kept at Lincoln, and was used for stationary boiler duty as late as 1962. It was put on display at the Colorado Railroad Museum in Golden in 1963. Next to it is the 4002, a 4-6-4 built for fast passenger service. However, its duties were limited to such mundane assignments as moving empty passenger equipment for football specials to and from Omaha. The future belonged to the diesel, such as the month-old GP9 No. 273 at right. Regular steam operation out of Lincoln ended in 1957. (William W. Kratville.)

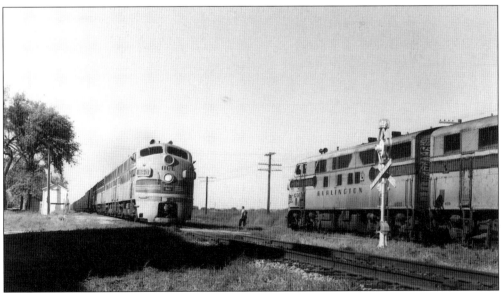

Westbound Burlington freight No. 75 (right) waits in the clear for No. 80 to head east through Merna, near the eastern edge of the Nebraska Sandhills, on October 13, 1964. In the lead are F3 cab units, built by General Motors' Electro-Motive Division. The Burlington called them graybacks, referring to their whitish-gray color scheme. The F units, starting with the first FTs in the early 1940s, began dieselization of main line freight service. (Francis G. Gschwind.)

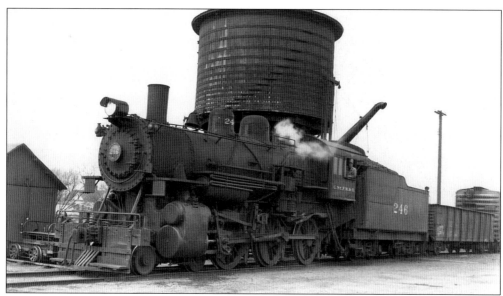

The Chicago, St. Paul, Minneapolis & Omaha Railway operated over 300 miles of track in northeast Nebraska. It had been controlled by the Chicago & North Western but was operated separately until 1957. This territory became one of the last holdouts for "Omaha Road" steam power, lasting until the mid-1950s. Ten Wheeler No. 246 takes water at Oakland in November 1947. Almost all Omaha Road trackage in Nebraska has since been abandoned. (William W. Kratville.)

Burlington GP9 No. 276, shown at Lincoln in 1955, was one of a seemingly limitless fleet of "Geeps" or road switchers. These EMD products were designed to do everything from switching to powering freight and passenger trains. They could be coupled together to operate in tandem by a single crew. Their versatility doomed the remaining steam operation in branch line and local freight service. The Burlington initially painted them black and gray, but the black was replaced by a vivid "Chinese red" in 1959. Many of the older Geeps got the Cascade green of the new Burlington Northern when it was created by merger in 1970. (Richard L. Rumbolz, Alfred J. Holck collection.)

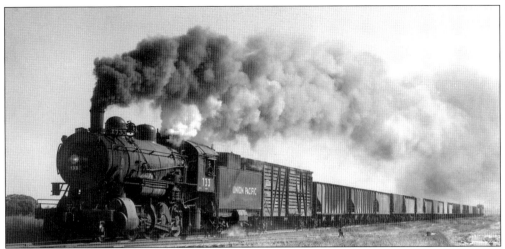

By 1957 the days of steam on Nebraska railroads were gone or in deep autumn. Union Pacific 2-8-0 No. 733, shown near Costin, west of Northport, with an extra freight on October 26, 1957, was making the last steam run on the North Platte Branch. This line, pushed into eastern Wyoming in the early 1920s, was most known for livestock and sugar beet traffic in these years. Since 1984, it has been transformed into a busy coal corridor from Wyoming's Powder River Basin. (Richard H. Kindig.)

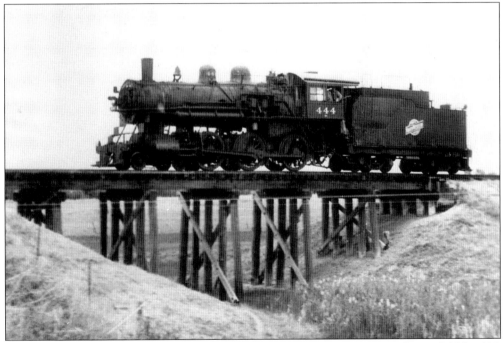

The last Chicago & North Western-owned steam locomotive to operate was R-1 4-6-0 No. 444. It had been stored in the Chadron roundhouse, but on June 13, 1958, it was heading west to Crawford. From there the Burlington would take it to its new owner, Black Hills Central Railroad at Hill City, South Dakota. The BHC, one of the nation's first tourist railroads, displayed the 444 at "Oblivion," midway between Hill City and Keystone, for several years. It's now at the Forney Transportation Museum in Denver. (Warren Wittekind, Michael Varney collection.)

Railroad roundhouses varied in size from a few stalls to almost complete circles, but all used the same basic design. Radial tracks fanned out into the building, usually off a turntable. Steam locomotives were run inside for servicing between runs and minor repairs. This was the interior of the Union Pacific roundhouse at Gering not long before it was razed. Diesel locomotive maintenance was concentrated at fewer points and used modern rectangular buildings.

Some roundhouses fell into disuse before they were finally torn down. This one served the Burlington at Ravenna into the 1950s, when steam operation ended. Removal of the turntable in 1961 isolated it from the rest of the yard trackage, but it stood into the 1980s, as shown here. In the diesel era, trains ran through Ravenna without changing locomotives. Train crews are still changed here, as Ravenna is the boundary between Burlington Northern & Santa Fe's Nebraska and Powder River divisions.

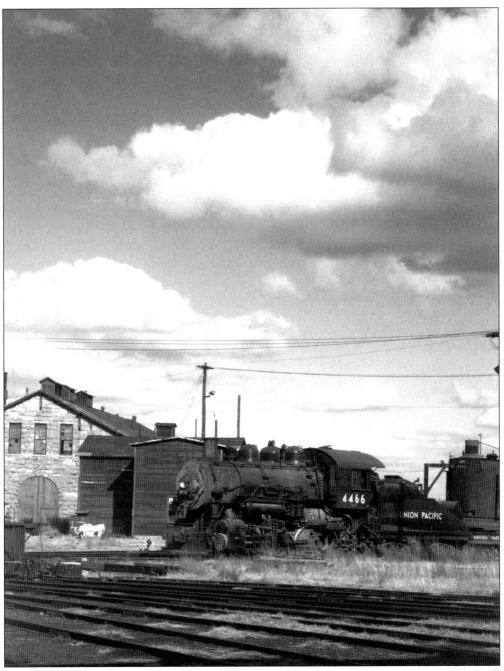

Union Pacific 0-6-0 switcher No. 4466 was the last steam locomotive stored at Grand Island, where it was parked after its last use in the fall of 1958. After the roundhouse was torn down, it sat outside for another 10 years until March 1973. At that time, UP refurbished it for cosmetic display at what would become the California State Railroad Museum in Sacramento. The museum restored it to operating condition in 1984 to haul visitors on the museum's six-mile Sacramento Southern tourist railroad. (John H. Conant, James J. Reisdorff collection.)

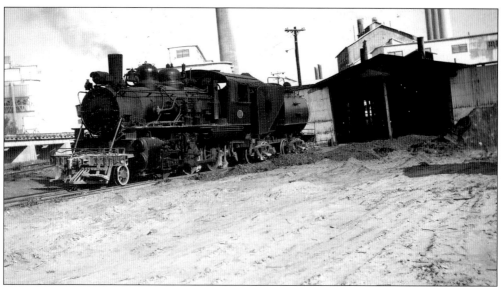

Ideal Cement Co. maintained a plant west of Superior and a short interstate railroad to the quarry in Kansas. One of its locomotives was No. 26, shown in May 1954. It had come from a short-line railroad in Arkansas also owned by Ideal. By 1960 diesels had replaced steam here too. The 26 was sold to a man from Concordia, Kansas, who wanted to operate excursion trains. When those hopes went unrealized, the engine was acquired by Illinois Railway Museum in 1974. The museum in Union, Illinois, wants to restore it for operation. (Richard C. Kistler.)

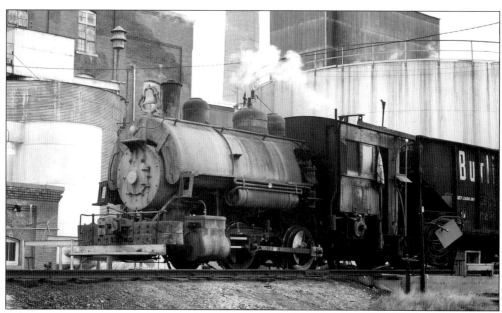

The last steam locomotives seeing regular duty in Nebraska were the Great Western Sugar Co. "dinkies" used at the refineries at Bayard, Gering, Mitchell, and Scottsbluff. Strictly utilitarian, the 0-4-0Ts were fired up to switch carloads of sugar beets during the campaign each fall and winter. Their use ended in the mid-1970s. All of the last locomotives used were preserved. This one, photographed at Scottsbluff in the fall of 1972, was purchased by a private individual and moved to a farm near Wood River. (Lawrence Gibbs.)

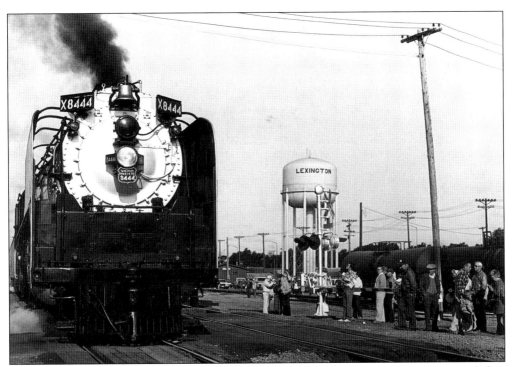

Union Pacific never retired 4-8-4 No. 844 (page 73) after regular steam operation ended in 1959. It was fired up for special occasions and visited almost every part of the original UP system, in addition to Chicago and New Orleans. (It was No. 8444 from 1962 until 1989 to avoid conflicting with a diesel locomotive number.) One tradition begun in September 1983 was the annual special train from North Platte to Omaha for the latter's River City Roundup. The first of these (pictured here) makes a stop at Lexington. Local officials, dignitaries, and school groups all got chances to ride.

The Union Pacific's 4-8-4 No. 8444 was a goodwill ambassador for UP, drawing large crowds and media attention wherever it went. Here, it was welcomed to Valley on one of its almost annual trips powering the special train to Omaha for River City Roundup. The last of these ran in 1991 (powered by a diesel) but the 4-8-4, back to its original number, 844, has been back since then. As of 2002, it's undergoing a major overhaul at its home base of Cheyenne, Wyoming. It's expected to be back on the road in coming years.

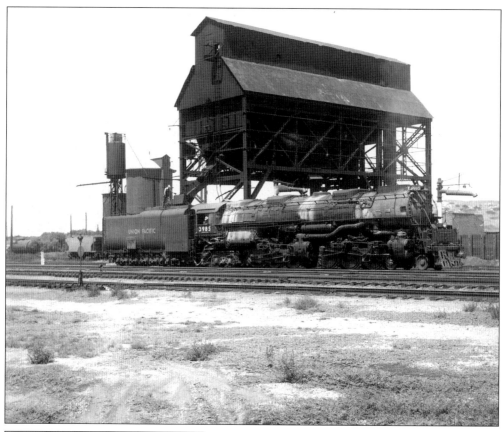

The end of steam also meant the end of the massive facilities used to service the locomotives, such as the Union Pacific coaling tower in Sidney. Challenger No. 3985 was just another of the big steamers that operated between North Platte and Cheyenne, Wyoming. The last regular use of UP steam was on this route, on July 23, 1959. The 3985 was later put on display near the Cheyenne depot. By 1981, however, it had been restored for excursion service. (Virl Davis, James J. Reisdorff collection.)

Railroads put windmills to use just as farmers and ranchers did, using wind power to fill isolated water tanks. However, extended calm periods could leave the tanks unreplenished, a situation that was known to disrupt rail schedules on occasion. Some tanks were equipped with pump engines to improve reliability. Municipal water was purchased at some locations. Windmill State Recreation Area, at the Interstate 80 Gibbon exit, commemorates the era. This railroad windmill, over 60 feet tall, was first erected by the Chicago, Burlington & Quincy at a small town in northeastern Colorado in about 1890. It was retired from railroad service in 1955.

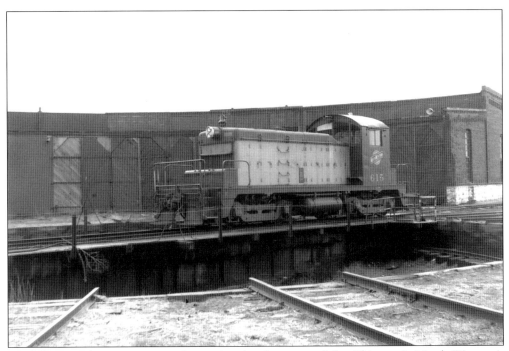

Norfolk was a busy junction and served as headquarters of the Chicago & North Western's Nebraska Division until 1969. A 16-stall roundhouse in the South Norfolk yard served steam locomotives based here. It was used less in the diesel era, although the local switch engine (pictured here), SW1 No. 615, had a ride on the turntable on April 29, 1973. The roundhouse was torn down in 1996. (Richard L. Schmeling.)

A large Union Pacific coal chute to refuel steam locomotives once dominated east Kearney. The coal chute is long gone, but it lives on in the name of the road that ran past. Across Nebraska there are many Depot Streets, Railroad Avenues, and Burlington Avenues, reflecting how railroads shaped community development. Coal Chute Road remains, in part due to the need to name all county roads for emergency response purposes.

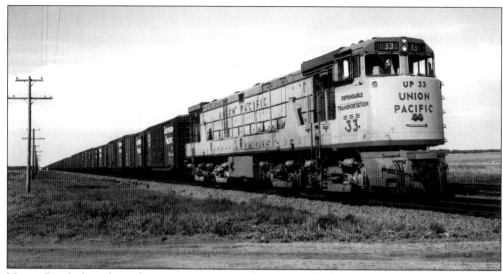

Union Pacific has always been an innovator in locomotive technology. In the 1960s, it bought "double diesels" from the three major builders. Each had two engines inside to boost horsepower. Especially common in Nebraska were General Electric's U50s, such as No. 33, on a westbound west of Clarks on June 5, 1966. But their uniqueness became a liability when railroads began widespread pooling of motive power for run-through freight trains. Mass-produced models like Electro-Motive's SD40-2 were preferred over "oddballs." Most of the U50s were traded in for newer locomotives in 1974. (Forrest H. Bahm.)

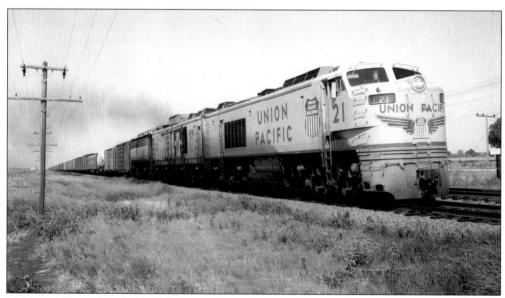

Unique to Union Pacific were the gas turbine electrics. The first production model arrived from General Electric in January 1952. A total of 55 were received through 1961. Here, turbine No. 21 is shown on a westbound freight west of Paddock (west of Central City) on July 4, 1966. Use of turbines in freight service ended in 1969. They generated up to 8,500 horsepower but were costly to maintain and required separate facilities. They also used large quantities of fuel. They were noisy too, and thus nicknamed "Big Blows." A few have been preserved, though none in operating condition. (Forrest H. Bahm.)

Seven

DECLINE OF THE
PASSENGER TRAIN

In October 1927, the Chicago & North Western replaced the steam passenger train on its line between Fremont and Superior with a gas-electric motor car to reduce operating expenses. But declining passenger traffic brought an end even to motor service on June 14, 1935. The last motor run is shown at Dwight. The conductor is identified as S.E. Holloman. A combination baggage-coach was then put on the local freight train for anyone still wanting to ride. This accommodation lasted until the late 1950s. (Alfred Novacek collection.)

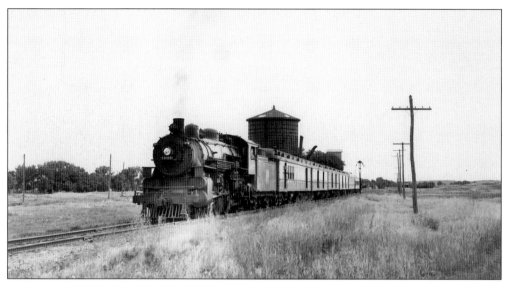

Chicago & North Western trains Nos. 13 and 14 had been the lifeline between Omaha and Chadron. They carried the mail and express, in addition to passengers, and were the most reliable form of all-weather transportation. One is making a stop at Crookston in the Sandhills on August 10, 1952. But the C&NW claimed the trains lost money and fought the Nebraska State Railway Commission for several years before obtaining permission to discontinue them. They were removed over a holiday weekend in July 1958, after the railroad obtained a favorable Nebraska Supreme Court ruling. (William W. Kratville.)

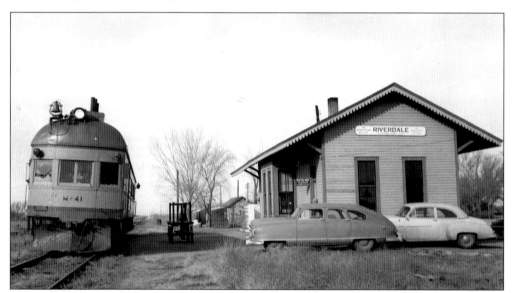

Union Pacific pioneered the use of internal combustion power to haul passengers. The first McKeen motor car, a predecessor of the modern diesel, began service between Kearney and Callaway on August 21, 1905. Fifty years later, motor service ended on the same branch line. A more modern version of a "doodlebug" is about to complete its last run from Stapleton on December 31, 1955. After leaving Riverdale, it will be on the last lap to Kearney. The M-41 was donated to Stapleton for display in 1958, but was scrapped in 1961 due to vandalism. (Francis G. Gschwind.)

Westbound Burlington passenger train No. 43 pauses at Crawford en route from Omaha to Billings, Montana, on March 12, 1968. In earlier years, it had carried a diner and a Pullman sleeper, plus additional mail and express cars, but now it's down to a minimum two-car consist. It had already survived an attempt to discontinue service west of Alliance in 1967. Within months, the CB&Q sought to eliminate the entire Omaha-Billings run, triggering one of the more contentious train-off battles before the Interstate Commerce Commission. Service ended amid controversy in August 1969. (Alfred J. Holck.)

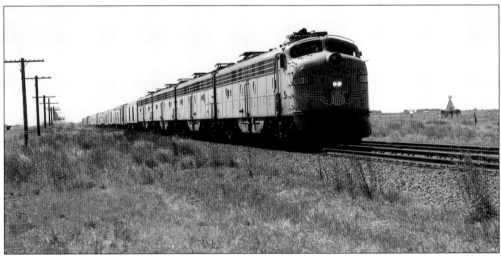

Union Pacific mail and express trains Nos. 5 and 6, and companion passenger trains Nos. 7 and 8, were familiar to daytime travelers in Nebraska, unlike the Streamliners that largely passed through at night and stopped at only the largest cities. The two pairs of day trains were combined in September 1965, but still carried many cars of mail and express. Here eastbound No. 6 is three miles west of Grand Island, one of its major stops, on August 26, 1967. Soon, however, the mail and express would be diverted to freight trains or other modes of transportation. Down to just three cars, Nos. 5 and 6 still lasted until October 1969. The sign at right is for an Indian-motif attraction along US-30, which had lost much of its through traffic to Interstate 80 in the 1960s. (Forrest H. Bahm.)

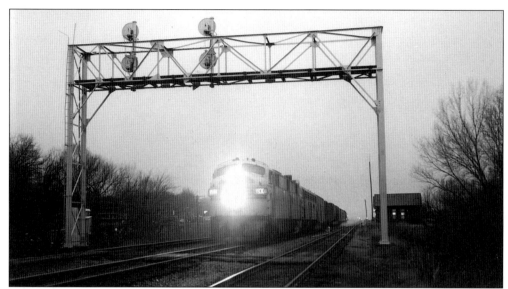

Burlington passenger trains Nos. 7 and 8 were the unremarked workhorses of the Chicago-Denver run. They carried large quantities of mail and express and stopped at many of the small towns skipped by the Zephyrs. Schedules usually called for them to meet at or near Lincoln. In this photo, eastbound No. 8 heads into the evening gloom at Ashland on December 16, 1967. The train would complete its last run from Denver to Omaha within a few days. The Omaha-Chicago segment had been combined with the Ak-Sar-Ben Zephyr earlier in the year. (William W. Kratville.)

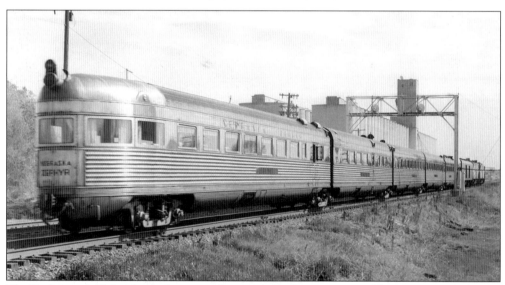

The Burlington's Nebraska Zephyr is just beginning its daytime run to Chicago as it streaks past North Twenty-Seventh Street in Lincoln in May 1967. The five-car train and its twin set were the last of the custom articulated streamliners of the 1930s still in use. The two had been built in 1936 for Chicago-Minneapolis service as the Morning and Afternoon Zephyrs, then were shifted to the Chicago-Omaha-Lincoln run in November 1947. By 1967, two cars had been permanently taken from each consist. The trains were removed from service in January 1968. One set is at the Illinois Railway Museum at Union, Illinois. The other ended up in Saudi Arabia after being purchased by the Saudi government. (William W. Kratville.)

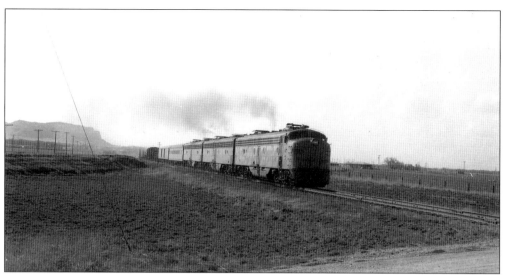

Mixed trains, carrying both freight and passenger cars, were common on many secondary lines. One of the last true mixeds ran up the North Platte Valley from North Platte to South Torrington, Wyoming, via the Union Pacific. No. 54, pictured here, leaves Gering for the last time on April 30, 1971. Amtrak's debut the next day would end these passenger accommodations, leaving the line with freight service only. Scotts Bluff, a major landmark on the Oregon Trail and now a national monument, is in the background. (Virl Davis, James J. Reisdorff collection.)

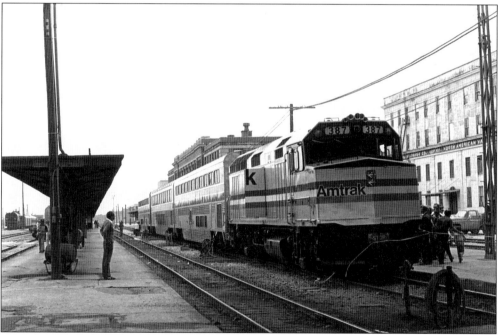

Amtrak re-equipped the San Francisco Zephyr that crossed Nebraska with new Superliner cars in mid-1980. A sample consist was displayed at Lincoln on October 11, 1981. Although not visible in the photo, a line of people waiting to tour the train extended back through the depot and up the sidewalk on P Street. Modern rail passenger equipment could still draw crowds to the depot, just as the first Burlington Zephyr did in 1934.

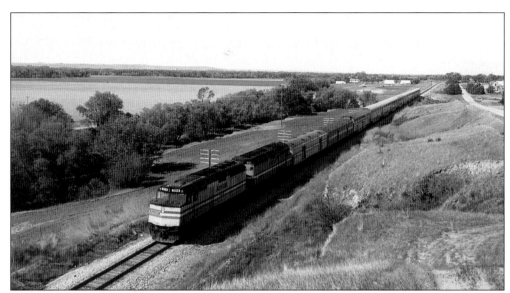

Amtrak's eastbound California Zephyr normally passes through southwest Nebraska after dark. But due to delays en route, passengers aboard No. 6 on May 19, 1986, were able to enjoy the view of the scenic narrows east of McCook. This serene scene is in sharp contrast to the devastation that hit the Republican Valley in the May 1935 flood disaster.

Amtrak's eastbound California Zephyr, running behind schedule, makes its regular stop at Omaha on June 15, 1998. The large depot to the right is the former Union Station, now occupied by the Durham Western Heritage Museum. The unused Burlington Station is toward the rear of the train. The Amtrak depot, a modern brick facility built in 1983, is to the left. From here the train will head south to cross the Missouri River at Plattsmouth, en route to Chicago. The "Genesis" diesel units like this were acquired by Amtrak in the 1990s. The national rail passenger system has been part of Nebraska life for 31 years and has had to fight for survival several times.

This view at Columbus harkens back to the golden age of the streamlined train in the 1950s and 1960s, when such scenes were everyday occurrences, if usually after dark here. But this is a rare view from September 10, 2000, when Union Pacific ran a special train from Council Bluffs, Iowa, to Columbus and back for representatives of the short lines and regional railroads it does business with. The depot is the last passenger-era facility still on site at an intermediate point on the UP main line between Omaha and Cheyenne, Wyoming.

Special passenger trains on branch lines are rare indeed. The Camerail Club of Omaha, a group of rail enthusiasts, sponsored a two-day excursion out of Columbus on three Nebraska Central Railroad branches leased from Union Pacific. Passengers enjoyed a barbecue lunch at Spalding on October 22, 1995, while the train shown here was prepared for the return trip. Forty years to the day earlier, the Camerail Club had added two extra cars to the regular UP mixed train to Spalding to experience the last days of steam power on the branches.

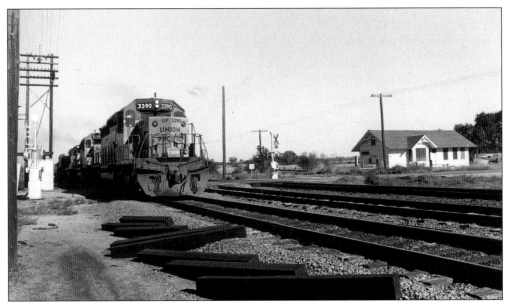

The Paxton Union Pacific depot had stood next to the tracks for decades, serving as the town's link to the world. But when local passenger travel shifted to the auto, railroads concentrated on carload freight instead of smaller merchandise shipments, and new technology eliminated the need for staffed depots at most towns. The UP main line is busier than ever, but the depot was sold and moved to a new site. Today, it's just a bystander to the action. (Nebraska State Historical Society.)

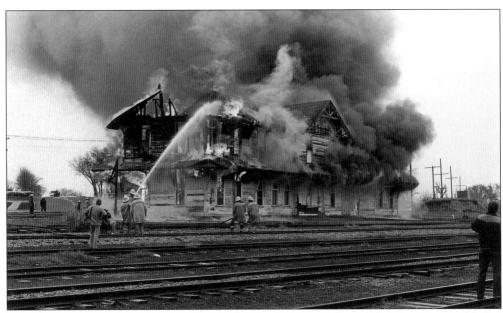

Time ran out for the old Burlington depot and office building at Wymore on April 1, 1984. It had been the hub of the Wymore Division since the 1880s. An eating house just to the east served travelers and railroaders, but traffic was shifted to other lines and Wymore became a Burlington backwater. Dispatchers and most other officials were moved to Lincoln in the 1950s. The depot hosted its last passenger train on February 24, 1962. Completion of a small metal replacement building in late 1983 eliminated any further role for the depot—except for fire training.

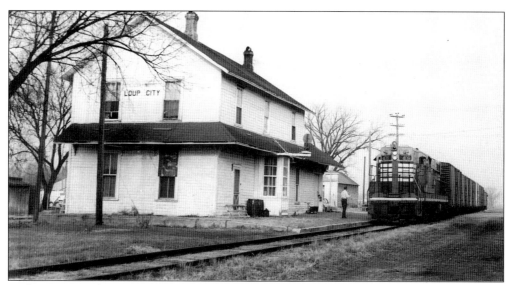

Burlington mixed train No. 58, en route from Sargent to Aurora and Hastings, rolls into Loup City on November 21, 1966. Passengers could ride the combination baggage-coach car, but ridership on the mixeds was negligible in later years, mainly consisting of railfans and school groups. The Burlington got permission to discontinue such service statewide in 1968. Freight service continued through Loup City until 1985 when the Sargent branch was abandoned west of Palmer. The depot stood idle for years until being burned down for fire training on August 24, 2000. (Francis G. Gschwind.)

While the adjoining steel rails stretch out to infinity, the future of the Union Pacific depot at Silver Creek was finite by the summer of 1971. The agency here had closed two years earlier. Some depots were moved, in whole or in part, to new sites for reuse. But others, like Silver Creek, were salvaged for their materials. (*The Columbus Telegram*, James J. Reisdorff collection.)

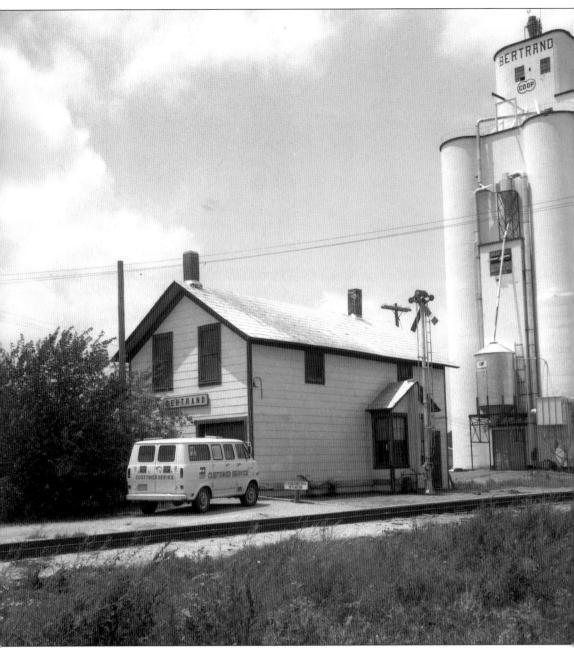

By the late 1960s, railroads replaced fixed agencies in many towns with mobile vans, so that one agent could call on shippers in several different communities. A Burlington Northern mobile agency van, which otherwise still sported markings for the pre-1970 Chicago, Burlington & Quincy, served several towns on the "Hi-Line" (page 56) out of its base at Bertrand. Pictured during July 1977, the depot, one of the standard Lines West two-story classics, later became a sand and gravel company office near Overton. (Michael M. Bartels.)

Milligan was made the base for an early Burlington mobile agency in 1969, but the depot here was torn down in 1978 after the mobile base was moved to Geneva, as the sign on the door indicates. The mobile itself was discontinued a few years later. They proved to be just a transition from the local agent to centralized customer service centers, contacted via telephone or computer. (Michael M. Bartels.)

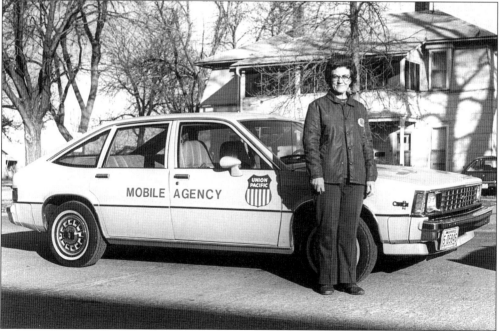

Mobile agencies underwent a change, from the first "bread trucks" that were full offices on wheels to more roadworthy vans, then station wagons, and finally ordinary passenger cars. Ann Sedlak was a mobile agent on a route that served David City, Rising City, and Brainard. The UP later parked the mobiles, painted in trademark yellow and red colors, preferring instead a single customer service center, which served the whole system from St. Louis. (*The Banner-Press*, James J. Reisdorff collection.)

Not all depots could be saved. Efforts to preserve the limestone depot at Valley were stymied by the high cost to move the structure, which had also suffered flood damage in 1978. Union Pacific let members of the local historical society hold a "last look" event on June 29, 1980. (Nebraska State Historical Society.)

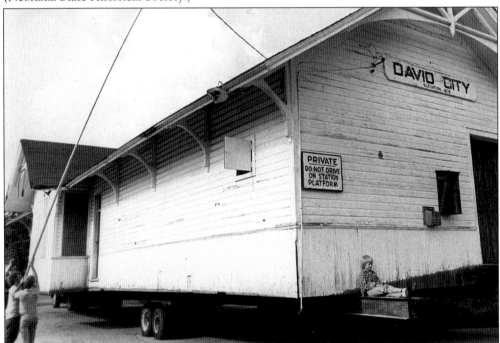

In past years, people went to the Union Pacific depot in David City to get a ride. On May 18, 1977, a child caught a ride on the depot itself, en route to its new site two blocks to the north. Its new owner converted it into a duplex. The depot office closed in 1973, when a mobile agency van took over. (*The Banner-Press*, James J. Reisdorff collection.)

Eight
FREIGHT TRAIN RENAISSANCE

"Flat" Nebraska has a segment of mountain railroading in the northwestern Panhandle, where the Burlington encountered the rugged Pine Ridge between Hemingford and Crawford. Rail activity surged with the Wyoming coal boom starting in the 1970s. A Burlington Northern coal train from the early 1980s is shown ascending Crawford Hill. Even today extra diesel units are added at Crawford for the climb to the top of the grade. Another significant grade in western Nebraska is Angora Hill, northeast from Northport toward Alliance. The BNSF has proposed a new line that would reduce the grade, but this is being fought in court by landowners. (*The Chadron Record*, James J. Reisdorff collection.)

In addition to full-fledged towns, there were many small shipping points across Nebraska consisting of just a grain elevator, in addition to perhaps a store and several houses. Nimburg, in northeast Butler County on the Burlington's branch line to Schuyler, was one of them. It lost its rail access in November 1941, when service was cut back to Prague, but the old elevator has long stood to mark the site of Nimburg. Just a few miles to the northwest was Edholm, a similar station on the CB&Q. To the southeast in Saunders County was the slightly larger community of Rescue.

The diesel had replaced steam power, but this March 27, 1965 scene of the Union Pacific at Shelby still evoked past years. Covered hoppers replaced the once-ubiquitous boxcars for grain transportation. They were assembled into solid unit trains and operated as needed, compared with the traditional local freight that generally followed a regular schedule, often three trips a week. The UP leased this branch line and four others to the new Nebraska Central Railroad in June 1993. The local co-op, now part of a much larger organization, built a new elevator just east of town and even leases its own diesel switch engine. (Forrest H. Bahm.)

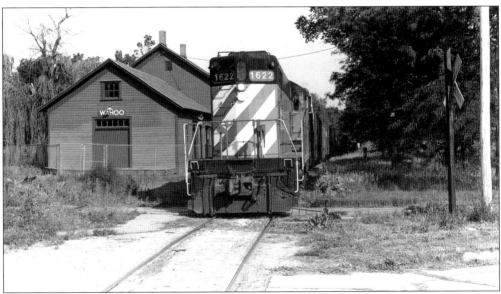

The former Burlington depot at Wahoo had been fenced off from the track as part of its new role as a Saunders County Historical Society museum, but trains still rolled past it as before. On July 3, 1980, GP7 No. 1622 waits for a new crew to continue its trip up the low-speed branch from Ashland to Prague, end of the line since the 1941 cutback from Schuyler. Flood damage in June 1982 ended service here, followed by rail removal a year later. The depot, now owned by the society, remains on site. It was undergoing major renovation in 2002. (Nebraska State Historical Society.)

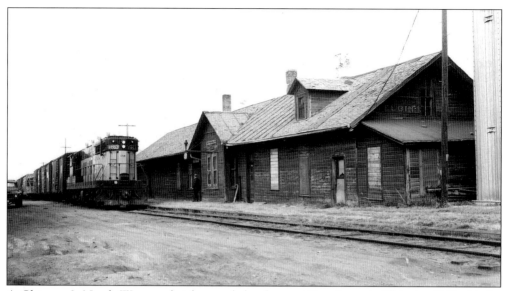

A Chicago & North Western freight crawls by the rambling depot in Elgin in 1966. At the time, the road still operated the west end of its Albion line, from Oakdale to Newman Grove. The segment east to Scribner had been abandoned in 1961 after a long battle with the Interstate Commerce Commission. The line was dubbed "the crookedest railroad in Nebraska" as it made its way through the rolling hills between the Platte and Elkhorn valleys. Track south of Elgin was removed beginning in 1972, leaving just the stub down from Oakdale. The last train came down from Oakdale in 1980. An Elgin grain dealer bought the line in hopes of restoring service but ended up salvaging it in 1983. (Francis G. Gschwind.)

As the number of out-of-service rail lines increased, "Exempt" signs began going up at crossings, freeing buses and gas transports from their legal duty to stop. By June 24, 1984, no Burlington Northern trains were expected to ever again cross US-34 east of Seward. This was the original line from Lincoln to Seward, completed in 1873, although another route (via Milford) in the early 1900s, transformed into the main line. The BN's local freight to Columbus used the old line until the early 1980s when it was rerouted via Milford.

Last runs often brought out railfans and local newspaper photographers. Here Chicago & North Western's Seward agent Charles Donnelly (left) hands over train orders to conductor Kenny Leland for the C&NW's last trip out of Seward on December 27, 1972. The railroad was abandoning its 84-mile branch line from Superior, plus trackage rights via the Burlington Northern between Seward and Lincoln. The Seward-Superior trackage was sold to a new short-line railroad, but it ran for less than a year. (Michael M. Bartels.)

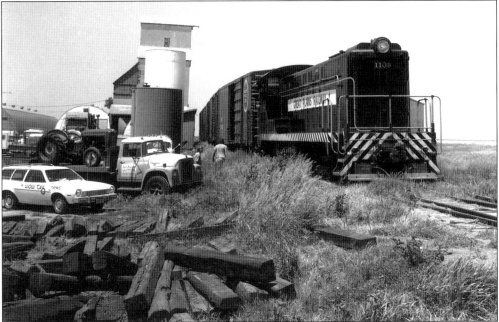

The Great Plains Railway was launched amid national publicity and praise from many quarters. Farmers and other local residents had purchased an 84-mile branch line from Seward to Superior abandoned by the Chicago & North Western. Its first train was completing the inaugural run from Superior to Nora on June 27, 1974. The track here at Nora was saved from a previous abandonment in 1938, when the Rock Island retreated from Nelson to Ruskin. The Nora elevator bought this short segment to connect with the C&NW on the east edge of town. However, low grain traffic and a severe winter would force the Great Plains to cease operation on April 15, 1975. The track was removed in 1976. (Michael M. Bartels.)

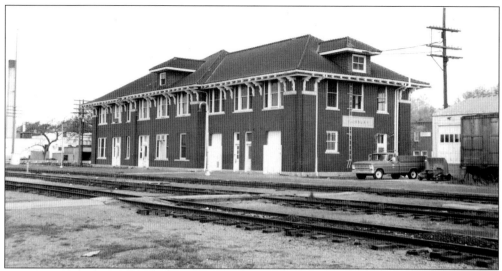

The Rock Island depot at Fairbury, pictured here in 1972, also served as headquarters of the railroad's Western Division. It was completed in 1914, replacing a depot that had burned. Passenger service here ended in October 1966. The depot was closed in April 1980, as the bankrupt Rock Island was shutting down for liquidation. The building stood abandoned until June 1992, when the Jefferson County Historical Society was able to get the title and begin restoration. It's now home to the Rock Island Depot Railroad Museum, honoring the memory of the railroad that once employed 600 people in town. (Thomas W. Jurgens.)

Four Missouri Pacific diesel units move a freight train north through Falls City on September 5, 1971. Falls City, midway between Omaha and Kansas City, landed the prized division headquarters, roundhouse, and shops by voting bonds in 1909 to buy the additional land needed. By 1924 the MoPac employed 671 here. But dieselization and centralization hit railroad towns like Falls City hard. The roundhouse closed in 1951 and the division headquarters migrated south in 1962. Crews still changed here until 1992, but now Union Pacific, which acquired MoPac in 1982, runs the crews through from Council Bluffs, Iowa, to Kansas City. (William F. Rapp.)

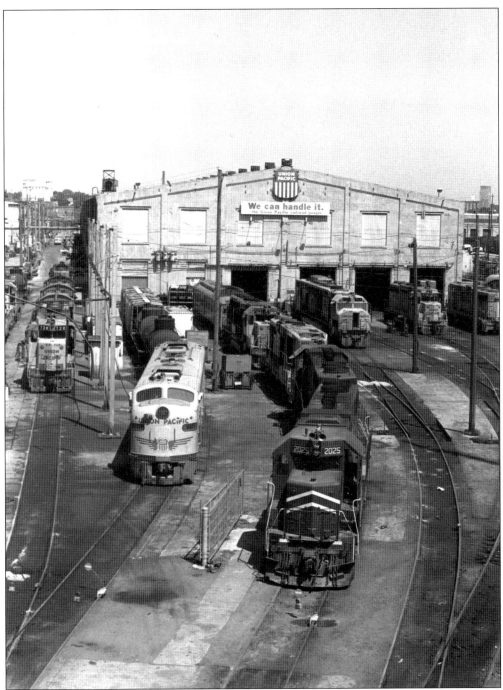

Omaha had been Union Pacific's primary repair shop location since the 1860s. This July 15, 1984 view, looking over the shops from Abbott Drive northeast of downtown, shows a busy scene. But following UP's acquisition of the Missouri Pacific in December 1982, it transferred heavy locomotive repairs to North Little Rock, Arkansas, in 1988. The remaining passenger car work in Omaha was shifted to Council Bluffs, Iowa, in 2001. The buildings have been razed and the area is being redeveloped for a new city convention center and arena.

The Chicago & North Western's 321-mile line across northern Nebraska carried on in relative obscurity for years. By the early 1990s, however, the fate of the struggling "Cowboy Line," as it had become known, was drawing railfans to document its now-weekly trains. This one was westbound at milepost 109, two miles east of Oakdale, on March 16, 1992.

The battle to save the C&NW's Cowboy Line across northern Nebraska was over. Now, on November 30, 1992, the crew of the last eastbound train from Chadron to Norfolk poses for a photo at Merriman. The last westbound train, which met this one at Long Pine, passed through Merriman on December 1. A compromise rail-trail agreement will see rail service restored over the 57.3 miles from Chadron to Merriman by the new Nebkota Railway in 1994. To the east, the 247 miles of track from Norfolk to Merriman would be removed and the right of way developed over a period of years by the Nebraska Game and Parks Commission as the Cowboy Trail—the longest rail-trail project in America.

This view of surplus Union Pacific cabooses in Omaha on July 15, 1984 was reminiscent of the ranks of steam locomotives stored in the 1950s. Like steamers, the caboose had been made obsolete by changing technology. Towns eagerly sought examples of both for display—and then often left them to rust. Cabooses were more versatile for reuse, being made into cabins, tourist information offices, and playrooms, in addition to display.

The caboose disappeared from the rear of most freight trains in the mid-1980s, but something new appeared by the late 1990s. New technology allowed diesel units to be placed anywhere within the train or on the rear and still be controlled by the engineer on the head end. This "distributed power" unit, with no one aboard, brings up the rear of a westbound Union Pacific empty coal train at Fairbury during September 1998.

Cars roll down the 34-foot hump of the eastbound classification yard at Union Pacific's Bailey Yard in North Platte during September 1996. Preblocking of trains helped reduce congestion at Kansas City. This was the second hump built at North Platte and was christened on October 25, 1968. Cost was $12.5 million. The original $3.5 million 1948 hump yard was then used to classify westbound traffic. It was replaced by a new $40.5 million westbound yard dedicated on July 20, 1980. Other trains, such as intermodal and coal trains, bypass the humps on run-through tracks, stopping only for servicing. Of the 10,000 cars going through Bailey Yard daily, about 3,000 are classified in the hump yards.

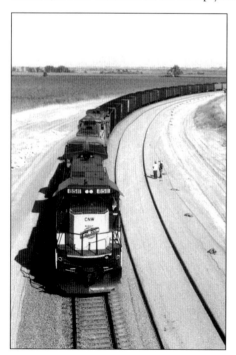

The Wyoming coal boom brought a renewal of railroad construction in Nebraska. Rather than rebuild its own deteriorated line across northern Nebraska, the Chicago & North Western built a shorter connection to the Union Pacific in the Nebraska Panhandle. It opened on August 16, 1984. Business was booming by the time of this photo on September 5, 1991. Already rails had been strung out for a second track to increase capacity. Union Pacific acquired the C&NW in 1995. By March 19, 2001, it had moved 100,000 loaded coal trains over the route via South Morrill since 1984.

Drivers in Bridgeport impatiently wait for a coal train to pass on January 18, 1981. Such conflicts became more frequent with the coal boom of the 1970s and 1980s, which dramatically increased rail traffic on lines coming east out of Wyoming. This brought demands for construction of overpasses, but funding is limited and residents often oppose closing of grade crossings as part of the package.

Another eastbound coal train "splits" Columbus in two during the summer of 2000. Like all towns along the Union Pacific main line, Columbus has experienced a significant increase in rail traffic in recent decades, primarily attributable to coal. Concerns have grown about blocked crossings, possible delays to emergency vehicles, noise, and inconvenience. The city has long had a viaduct on US-30&81, but getting a consensus on where to build a second one, and on related crossing closings that would be required, has been difficult.

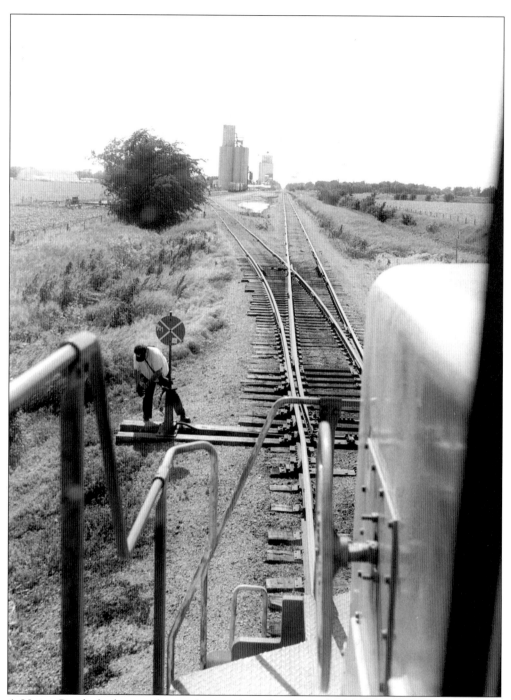

A Union Pacific brakeman throws the switch at the east end of the elevator siding at Shelby on June 22, 1993. Time was running out for UP operation of the Stromsburg Branch, a tradition extending back to the line's construction in the 1870s. Five days after this photo was taken, the new Nebraska Central Railroad took over this trackage under lease from UP. This transaction was just one of the growing trend of selling or leasing secondary routes to new regional carriers and short lines. Nebraska Central has now operated almost 10 years.

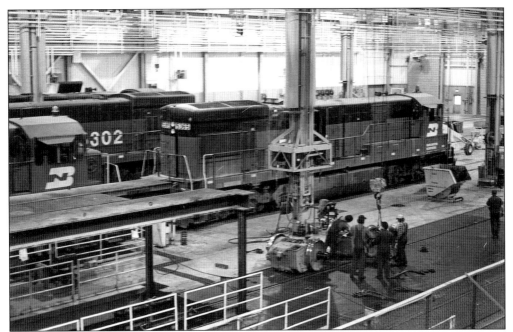

During the coal boom of the 1970s, Alliance quickly became one of the busiest points on the new Burlington Northern. Trainloads of Powder River Basin low-sulfur coal required a large force of employees for operation and maintenance. Symbolic of the change in Alliance's economy, the old livestock market had to vacate leased railroad land to make way for a new shop to service and maintain diesel locomotives. The rail shop and a companion car shop were dedicated on September 8, 1979. Landmarks from the earlier rail era, including the depot and roundhouse, also disappeared in the transition.

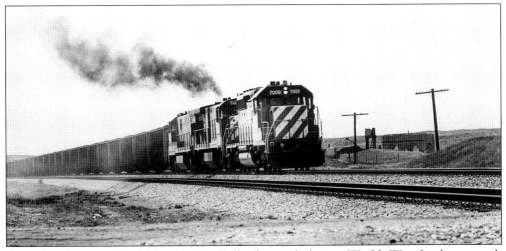

Antioch, deep in the Nebraska Sandhills, boomed during World War I when potash manufacturers turned to its alkali lakes after the normal sources of supply were cut off. The boom collapsed in the postwar years, leaving Antioch just another of the small settlements along the Burlington's lonely route east from Alliance. Only the ruins of the industry remain as a Burlington Northern coal train passes on June 8, 1988. The predecessor of today's Nebraska Highway 2 between Grand Island and Alliance was known as the Potash Highway.

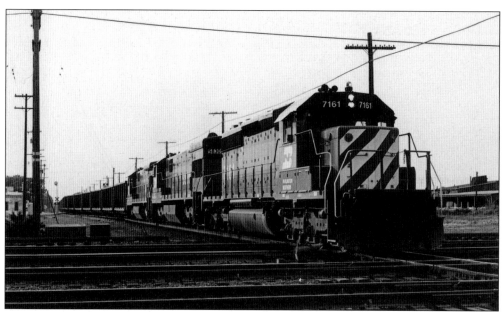

Grand Island has been a busy rail crossroads since the 1880s, when the Burlington laid track across the original Union Pacific main line. A manned tower out of sight to the left controlled train movements across the "diamonds" until that duty was moved elsewhere in May 1983. The UP had priority because it was there first. Traffic surged in the 1970s, after Burlington Northern began hauling trainloads of Wyoming coal east, such as this one on June 13, 1982. To eliminate delays waiting for UP trains to cross, BN elevated its line through Grand Island. Trains starting going over the UP on a new bridge on July 27, 1995.

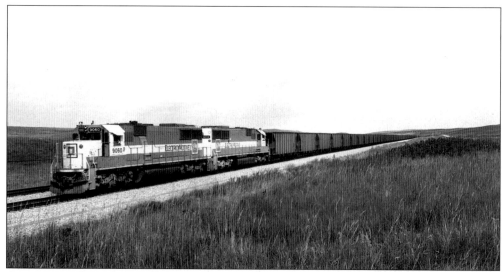

A common sight in the Sandhills is the seemingly endless parade of coal trains heading east and empties returning west. This view from August 1987 shows a westbound Burlington Northern train powered by two SD60s painted in the attractive blue and white colors of General Motors' Electro-Motive Division, which manufactured the pair. They were leased from Oakway Inc. on a "horsepower by the hour" basis. The Oakways contrasted with BN's sizable fleet of its own units painted in the Cascade green color scheme of the 1970 merger.

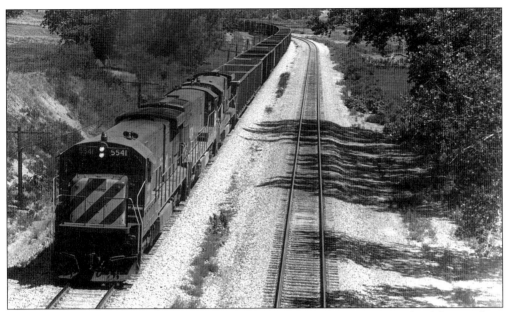

The Burlington and Nebraska Highway 2 are within sight of each other much of the way from Grand Island to Alliance, forming a busy commerce corridor through the lonely Sandhills that begin west of Anselmo. Here, an empty coal train headed west is about to pass under the highway overpass between Thedford and Seneca on June 29, 1989. Seneca, a former rail crew-change point, was one of the few towns bypassed by the improved highway. (Charles W. Bohi.)

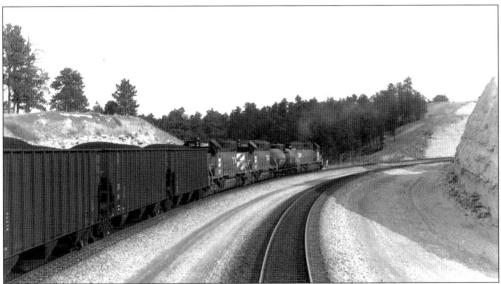

Crawford Hill, which has long been a hurdle to the Burlington in northwest Nebraska, required the creation of the state's only railroad tunnel. Even into the diesel era, helper engines have to be added at Crawford to provide additional power for the ascent up the Pine Ridge to the summit at Belmont. There they are cut off and return to Crawford to assist the next train. This 1989 view from the cab of a westbound shows pusher units on the rear of an eastbound coal train climbing the grade. The tank car carries additional diesel fuel for the locomotives to reduce the time needed for refueling. (A.J. Pfeiffer.)

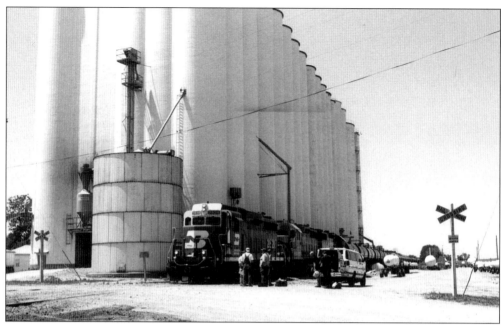

Burlington Northern retreated from Columbus to north of Bellwood in March 1984, so it could retire the long bridge over the Platte River. But a new bridge was built in 1995–1996 to let it serve a new Minnesota Corn Processors ethanol plant southeast of Columbus. Business also justified a daily local freight from Lincoln, although low track speed over portions of the branch line north of Seward made it impossible to complete a round trip in 12 hours, the legal limit on crew duty time. Here, the southbound local freight is getting a new crew at Bellwood to finish the trip to Lincoln during the summer of 1999. Vans like these, used to shuttle rail crews, became frequent sights on Nebraska highways.

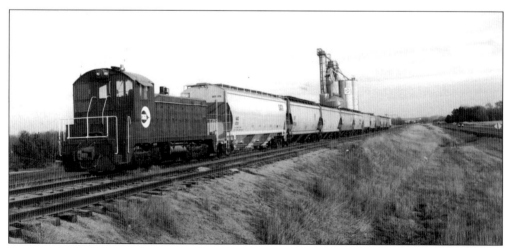

Some grain facilities are busy enough to justify use of their own switch engine. This Cargill elevator and loading facility is southeast of Ord along Nebraska Central. This scene also illustrates a new trend: remote control locomotive operation. As the large Class 1 railroads began implementing this technology in 2002, it brought protests from the Brotherhood of Locomotive Engineers. Conductors and switchmen were being trained to operate locomotives with remote control belt packs.

A Burlington Northern & Santa Fe grain train comes off the Benedict Spur onto the main line at York during the late 1990s. This short branch was one a few that has been upgraded to accommodate unit grain trains and large locomotives. Many others were considered to have inadequate revenue potential to justify the investment. Another branch line extending south from York to McCool Junction was abandoned in 1984. Both were once part of the Kansas City & Omaha Railway, which extended from Stromsburg to Alma and Endicott and was acquired by the Burlington in the early 1900s. Most of the former KC&O trackage has been abandoned.

Burlington Northern officials show off the latest in motive power to McCook business and civic leaders in early 1995. The road had ordered 350 of the new SD70MACs in March 1993, to be delivered over five years. In addition to their new olive and tan BN colors, they also marked a major change in diesel-electric locomotive technology. They used alternating current instead of the direct current that had long been the standard. AC traction offered greater pulling power at lower operating costs. (*McCook Daily Gazette*, James J. Reisdorff collection.)

An eastbound Burlington Northern intermodal freight pauses in McCook to change crews. This southwest Nebraska city remains an important point on Burlington Northern & Santa Fe's Lincoln-Denver line, even though it's no longer a division headquarters. The largely unused pedestrian walkway that connected the depot with the roundhouse area gives evidence of past activity. It has since been removed. A portion of the old roundhouse was incorporated into an agricultural chemical business.

Nine
PRESERVATION

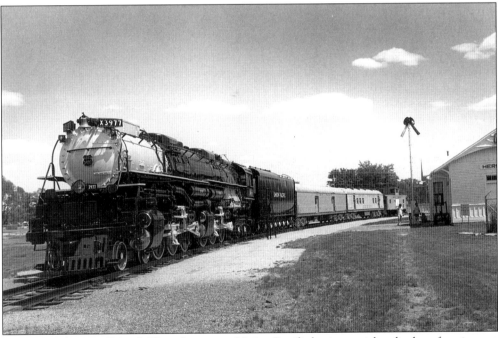

The railroad town of North Platte honors its Union Pacific heritage with a display of equipment and the depot from nearby Hershey at Cody Park. Volunteers help maintain the display and open it for tours during the summer. The 3977 is one of two preserved UP Challenger-type locomotives. In 2002 the locomotive was repainted two-tone gray, a short-lived postwar color scheme used on UP steam passenger locomotives. In its final years before donation, it was kept in the North Platte roundhouse for snow-melting duty in the large freight yard. Another UP steamer, 2-8-0 No. 480, is similarly well cared for in Memorial Park in southeast North Platte. The community is also raising money to build a "Golden Spike" observation tower for those visiting UP's Bailey Yard, the largest rail freight yard in the world.

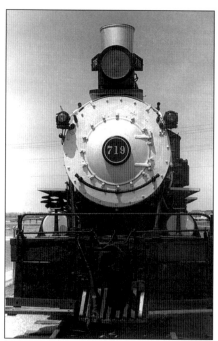

Burlington 4-6-0 No. 719 stands as a tribute to earlier days of railroading in Alliance. Its final years of regular operation as No. 919 on the lonely branch line from Sterling, Colorado, to Cheyenne, Wyoming, were well documented by a young Cheyenne rail photographer, James L. Ehernberger. It was last used in 1956, then stored at Lincoln until 1962. For display at Alliance, it was renumbered back to 719 and "backdated" to reflect its earlier appearance. It was later relocated to a different display site, a move that generated civic controversy over where it should go.

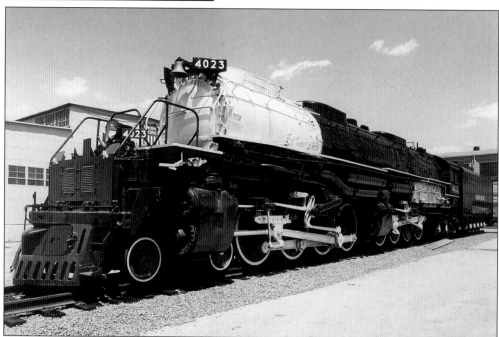

Big Boys weren't regular visitors to Omaha, but one has been preserved in Union Pacific's headquarters city. The 4023 was first placed outside UP's Omaha Shops, as shown here, in April 1975, visible from the main road downtown from the airport. It was moved to Kenefick Park a few blocks to the north in April 1988, along with an equally unique UP diesel, the first big Centennial DDA40X, No. 6900. With that site being taken for Omaha's new convention center and arena project, they were moved to Durham Western Heritage Museum at the former Union Station in May 2001. (Union Pacific Museum.)

Once technology, union agreements, and state law allowed elimination of most cabooses in the mid-1980s, many found new uses away from the tracks. North Platte hoped the sight of ex-Union Pacific caboose No. 25543 would draw passing travelers off the Interstate to seek more information about the city's attractions and services.

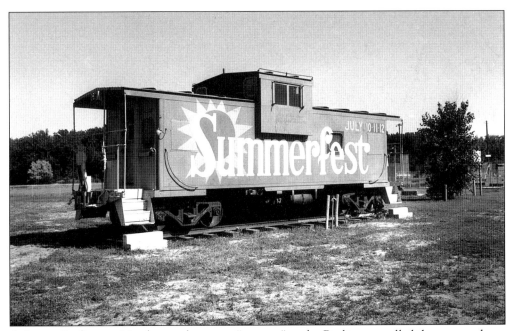

A former Burlington Northern caboose, or "way car" as the Burlington called them, served as a concession stand at the ballpark in O'Neill, as well as being a billboard for a local event. Other retired cabooses became cabins, game rooms, and party rooms at restaurants, museum displays, and even a "caboose motel" at Two Rivers State Recreation Area near Valley.

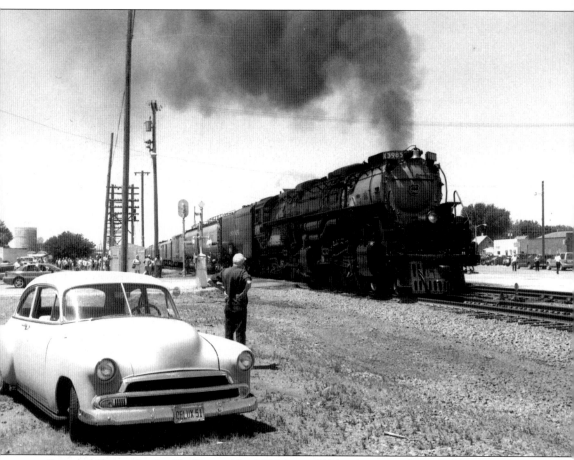

Restored Union Pacific Challenger No. 3985 (page 82) has been a welcome addition to the UP steam program, joining 4-8-4 No. 844. It made its first trip back to Nebraska in 1990. By then it had been converted to burn oil instead of coal. This was accomplished in part by removing the oil bunker from the tender of oil-burning sister engine No. 3977, on display in North Platte (page 115), for installation in the 3985's tender. Challenger 3985 has been the most frequent steam visitor to Nebraska in recent years, as the 844 has spent more time in the shop at its home base of Cheyenne, Wyoming. Here, the 3985 is shown at Columbus on June 8, 2001. A classic of the high iron meets a classic of the highway.

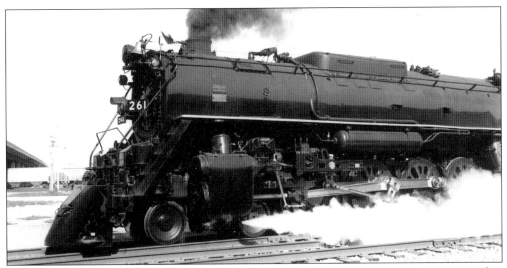

Unlike Union Pacific, Burlington Northern wasn't interested in heritage steam operation, but it has hosted several locomotives operated by others. One was ex-Milwaukee Road 4-8-4 No. 261, leased by a Minnesota group from the National Railroad Museum in Green Bay, Wisconsin. It made its first visit to Nebraska in September 1998, en route home to the Twin Cities after powering a series of employee appreciation specials for BNSF. The 261 returned in June 2000, and headed up three days of excursions out of Lincoln in conjunction with Operation Lifesaver, the grade-crossing safety-education organization.

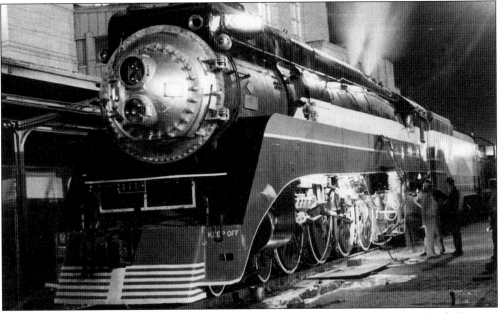

Ex-Southern Pacific "Daylight" 4-8-4 No. 4449 was retrieved from a park in Portland, Oregon, and restored to power the American Freedom Train around portions of the country in 1975–1976. Here it is repaired at the former Omaha Union Station in October 1975. Diesels took the trainload of Bicentennial-related exhibits on west. The 4449 caught up with it after a historic doubleheaded steam run across Nebraska behind Union Pacific 4-8-4 No. 8444. The original Freedom Train had visited several Nebraska cities in 1948. (Michael B. Foley.)

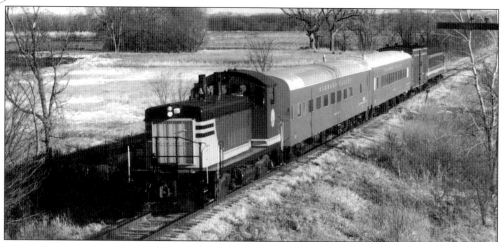

People can enjoy the pleasure of dinner in the dining car each weekend on the Fremont Dinner Train. It makes a three-hour round trip from Fremont to Hooper. The track and locomotive are shared with the Fremont & Elkhorn Valley Railroad. FEVR, owned by the Eastern Nebraska Chapter of the National Railway Historical Society, operates coach excursions April through October. It debuted in 1986, using 15 miles of ex-Chicago & North Western track, once part of C&NW's main line to northern Nebraska. Steam was used in FEVR's first years. The chapter hopes to restore another "iron horse" for regular operation. (Charles Furst.)

Steam returned to Omaha in 1968 when a 30-inch gauge railroad opened at Henry Doorly Zoo. A five-eighths size replica of Union Pacific "Golden Spike" 4-4-0 No. 119, manufactured by Crown Metal Products, took zoo visitors on a circuit around the grounds. It was later joined by this Austrian-built 0-6-2T that had been used in regular service in Romania. Smaller-scale live steamers operated at Goehner and Camp Creek near Waverly, plus on individually-owned properties. (James J. Reisdorff collection.)

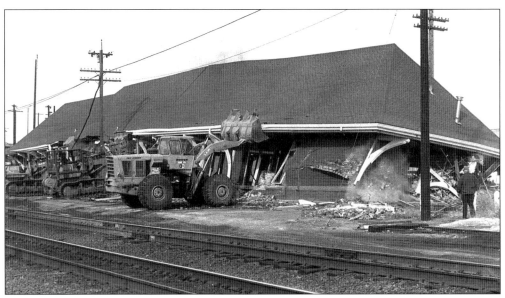

A well-organized but ultimately futile effort tried to save the 1891 Union Pacific passenger depot at Kearney, which the road had vacated for smaller offices in July 1979. The Save the Depot Committee sold calendars and T-shirts to raise money, but fell short of the estimated $50,000 moving cost. The UP did let the commiteee hold a "farewell to the depot" on February 8, 1981. Days later, after interior walls had been removed, the exterior fell to bulldozers on Friday the Thirteenth. Passenger service ended 10 years earlier with the start of Amtrak in May 1971. (*Kearney Daily Hub*, James J. Reisdorff collection.)

The Heartland Railroad Historical Society mounted a valiant effort to save the old Burlington roundhouse at Nebraska City, a five-stall structure used by the railroad until the 1950s. Even with several major collapses, the group was able to stave off condemnation and develop plans to rebuild the structure. On April 18, 2002, only days after this photo was taken, high winds blew down the south wall. Faced with the latest loss, the group conceded there was too little left to save.

An ordinary street sign can help preserve the memory of rail service to a community long after the fact, marking the location of the former depot and yard. For Prosser, northwest of Hastings, it had already been more than 50 years since the last Missouri Pacific train left town.

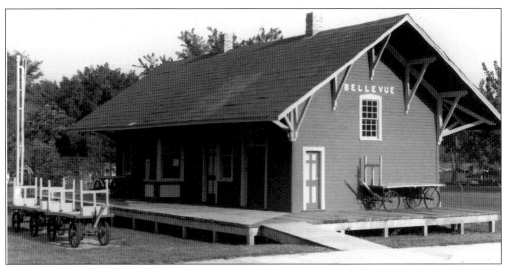

Among the many preserved depots in Nebraska is this one at Bellevue. It's believed to be the oldest existing depot in Nebraska, dating back to 1869, when the Omaha & South Western built south from Omaha toward the Platte River. It was soon acquired by the Burlington, forming part of the first rail link between Omaha and Lincoln. After the Bellevue depot was closed in 1966, it was moved to the city's Haworth Park. It has since been relocated to the Sarpy County Historical Society Museum grounds. Its size gives no hint that Bellevue, once a sleepy river town that time passed by, grew to become Nebraska's third largest city by 2000. (Nicholas L. Pitsch.)

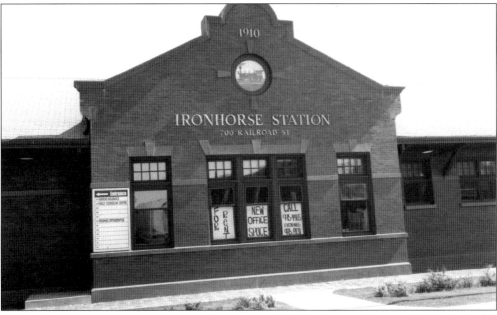

The 1910 Burlington depot at Holdrege was acquired by local developer Marvin Westcott, who transformed it into Ironhorse Station. In addition to providing a waiting room for Amtrak passengers, he created rental space for offices and developed a railroad park. Holdrege was the only city in Nebraska to regain passenger service after Amtrak's debut on May 1, 1971. It was initially left off the new schedule, but a stop was added two months later. Westcott also purchased the former Burlington roundhouse in Holdrege.

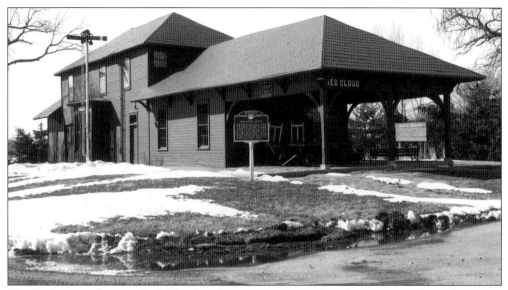

The Burlington depot at Red Cloud and its trains appeared in the writings of novelist Willa Cather, who spent much of her youth in Red Cloud and Webster County. In the early 1900s, Red Cloud's depot was the center of the community, commercially if not geographically. (It was so far south of the main part of town that it was linked to the rest of Red Cloud by a horse-drawn streetcar.) Passenger trains were gone by 1964, but that year, those interested in preserving Cather historic sites raised the funds needed to move most of the depot 300 feet north. It has been made into a museum by the Nebraska State Historical Society.

Some homes on wheels became stationary homes when their active days were over. Ivan Sundberg and his wife lived in the former Pullman sleeping car *Phillipines* during his years on a Burlington signal construction crew, which often took them to remote locations. When Sundberg retired, he bought the car from the railroad and had it moved to his property northwest of Stromsburg for use as a retirement home.

As railroads replaced the traditional track maintenance "speeders" with hi-rail trucks, which could travel by rail or road, the "putt-putts" found favor with hobbyists, who restored and even customized the machines. Trips under the auspices of groups like the North American Rail Car Operators Association were organized, usually on short lines or regional railroads. Motor car rides give a "low down" look at track that may not have had regular passenger service in decades. This outing is at Madison on the Nebraska Central on August 1, 1999.

Trains have provided a livelihood for many people. They are also a lifelong love for many, who may or may not have worked for a railroad. They were for Lou Koeppe, a college teacher of geography and avid rail historian who lived not far from the busy Union Pacific main line through Kearney. The family monument carries an image of one of UP's famous 4-8-4 steam locomotives.

As mentioned elsewhere in this book, recreational trail proponents in Nebraska have been successful in developing a number of abandoned railroad corridors as hike and bike trails, both within and between communities. One such popular rail trail is the Steamboat Trace, developed along former Burlington Northern right-of-way from south of Nebraska City to the Cooper Nuclear Station south of Brownville. Hopes to develop a tourist railroad here were lost in the mud and floods of 1993. In place, the trail runs along the base of high bluffs and along the Missouri River. Trail user Shari Reisdorff is shown near the small college town of Peru. The precautions on the sign are required emergency procedures for the nearby nuclear power plant.

From the days the first rails were laid in the 1860s, the Union Pacific main line across Nebraska has epitomized state-of-the-art railroading. That evolution continues into the 21st century, as shown in this scene near Sidney. Steam locomotives, passenger trains, and cabooses are gone. Freight trains are operated by two people instead of the five of the past, and it's been 30 years since crews were changed at Sidney on the North Platte-Cheyenne run. But today's trains are faster and carry more cargo than ever, which has been the basic quest of rail technology over these nearly 140 years.

BIBLIOGRAPHY

Bartels, Michael M., "River and Prairie Rails: Missouri Pacific in Nebraska," South Platte Press, David City, Neb., 1997.

Bartels, Michael M., "Rock Island Town: Fairbury, Nebraska, Western Division," South Platte Press, David City, 1999.

Bartels, Michael M., Kratville, William W., Mills, Rick, and Penry, Jerry, "The Chicago & North Western Cowboy Line. A History of the Longest Rail-to-Trail Project in Nebraska." South Platte Press, David City, 1998.

———, and Reisdorff, James J., "Ghost Railroads of Nebraska," South Platte Press, David City; Brueggenjohann/Reese Inc., Columbia, Mo.; J&L Lee Co., Lincoln, Neb., 2002

———, and Reisdorff, James J., "Railroad Stations in Nebraska: An Era of Use and Reuse," South Platte Press, David City, Taylor Publishing Co., Dallas, Texas, 1982.

Corbin, Bernard G., and Kerka, William F., "Steam Locomotives of the Burlington Route," Red Oak, Iowa, 1960.

Greene, Bob, "Once Upon a Town. The Miracle of the North Platte Canteen." William Morrow (HarperCollins), New York City, 2002.

Gschwind, Francis G., "Kearney & Black Hills," South Platte Press, David City, 1990.

Holck, Alfred J.J., "The Hub of Burlington Lines West," South Platte Press, David City, 1991.

Kistler, Richard C., "Burlington Route: The Wymore Story," Revised Edition, South Platte Press, David City; Brueggenjohann/Reese Inc., Columbia, Mo., 2001.

Klein, Maury, "Union Pacific: The Birth of a Railroad, 1862-1893," Doubleday & Co., Garden City, N.Y., 1987.

Klein, Maury, "Union Pacific Vol. II: The Rebirth, 1894-1969," Doubleday & Co., New York, London, Toronto, Sydney, Auckland, 1989.

Kratville, William W., "Knife-noses and portholes," *Trains*, Vol. 20, No. 9, July 1960, p. 30-39.

———, "Golden Rails," Kratville Publications, Omaha, Neb., 1965.

———, and Ranks, Harold E., "Motive Power of the Union Pacific," Barnhart Press, Omaha, 1958.

Lee, Thomas R., "Turbines Westward," T. Lee Publications, Clay Center, Kan., 1975.

Marre, Louis A., "Rock Island Diesel Locos, 1930-1980," Railfax Inc., Cincinnati, Ohio, 1982.

Mills, Rick W., and Reisdorff, James J., "Chicago & North Western, The High, Dry and Dusty," South Platte Press, David City, 1992.

Reisdorff, James J., "Wahoo Depot," South Platte Press, David City, 1985.

———, and Bahm, Forrest H., "Union Pacific's Stromsburg Branch. A Pictorial of a Rural Nebraska Railroad Line," South Platte Press, David City, 1987.

Strack, Don, "Union Pacific 1992 Annual," Hyrail Productions, Denver, Colo., 1992.

Wagner, F. Hol Jr., "1977-1980 Burlington Northern Annual," Motive Power Services, Denver, 1981.

The Banner Press (David City)
Beatrice Daily Sun
Columbus Telegram
The Crete News
The Diamond (Great Plains Chapter, National Railway Historical Society)
Fairbury Journal-News
Fremont Tribune
Grand Island Independent
Hastings Tribune
The Headlight (Stromsburg)
Kearney Hub
Lincoln Journal
Lincoln Journal Star
The Lincoln Star
The Main Line (Lincoln Rail Fans Club)
The Mixed Train (Camerail Club of Omaha)
The McCook Daily Gazette
The McCook Republican
Norfolk Daily News
North Platte Telegraph
Omaha World-Herald
Railfan & Railroad
Scottsbluff Star-Herald
Superior Express
Trains